New Views on Canadian Artists

J.E.H. *MacDonald*

Bruce Whiteman

Series Editor: Douglas Fetherling

J·E·H·MACDONALD

QUARRY PRESS

The publisher gratefully acknowledges the support
of the Department of the Secretary of State
(Canadian Studies Directorate), The Canada Council,
the Ontario Arts Council, the Department of
Canadian Heritage, and the Ontario Publishing Centre.

CANADIAN CATALOGUING IN PUBLICATION DATA

Whiteman, Bruce, 1952-
J.E.H. MacDonald
(New views on Canadian artists)
Includes bibliographical references.
ISBN 1-55082-131-8
1. MacDonald, J.E.H. (James Edward Hervey),
1873-1932. 2. Painters–Canada–Biography.
I. Title. II. Series.
ND249.M25W45 1995 759.11 C95-900152-2

Series Editor: Douglas Fetherling
Graphic Design: Peter Dorn RCA, FGDC
Copy Editing: Michael Dawber
Typesetting: Meagan Freer

Film and separations by The Linoshop, Belleville, Ontario.
Printed and bound in Hong Kong by Everbest Printing,
Hong Kong and Scarborough, Ontario.

Published by Quarry Press,
P.O. Box 1061, Kingston, Ontario K7L 4Y5.

Table of Contents

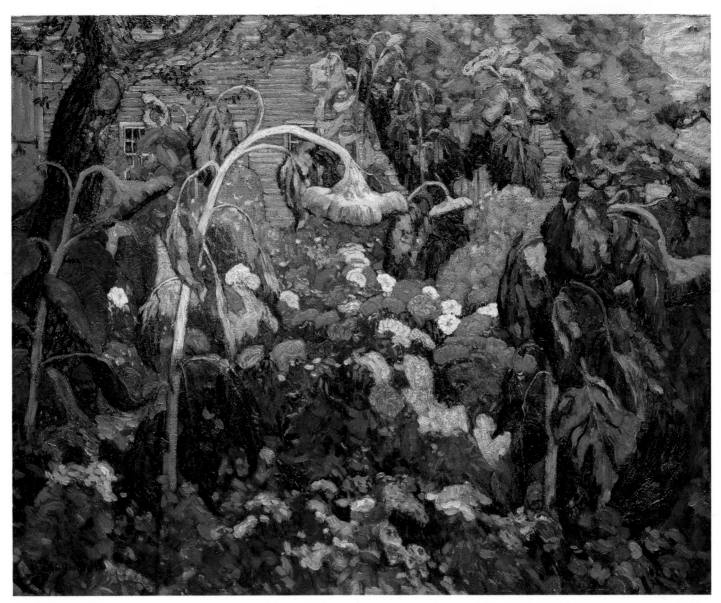

The Tangled Garden

Introducing
J.E.H.MacDonald

I F YOU WALK through the Canadian galleries in chronological order at the new National Gallery of Canada in Ottawa, you eventually arrive at Gallery No. 109. Coming into the room, the first painting you see is *The Solemn Land* by J.E.H. MacDonald, mounted on a wall by itself in the middle of the gallery. It is a large painting, flanked by two portrait busts, one of fellow Group of Seven member Frederick H. Varley by Florence Wyle, the other of Vilhjalmur Stefansson by Emanuel Hahn. Both sculptors were Toronto contemporaries of the Group of Seven, and the busts give the painting the air of a modest altar. The hallowed feeling is false, as the picture was not painted for a reredos, of course. Yet the response is not entirely inappropriate, for *The Solemn Land* is without question one of the icons of Canadian landscape art. It has been reproduced hundreds of times and exhibited often. The National Gallery bought it in 1921, the year it was painted, on the first occasion on which it was publicly shown. Many of MacDonald's other well-known paintings, by contrast, did not even sell during his lifetime, much less sell so immediately.

What is it about the painting that has made it so eloquent? Gaile McGregor, a literary critic, finds "the inimical face of nature" in much of the Group of Seven's work and explains its enduring interest by suggesting that *this* is the hostile quality in the natural world to which Canadians always respond. Clearly that cannot be the case here: the clouds certainly wear a threatening face, and the shadows flung across the cliff in the upper left portion of the image are slightly disquieting. But on the whole the tone of the picture is, well, solemn, not menacing. It is among the most classically composed of MacDonald's Algoma paintings, and its clarity of structure is in perfect step with its monumental presence and emotional stillness. The river is certainly moving,

as both the pigments and the brushstrokes suggest. But that movement cannot affect the stately panorama that MacDonald has created. If the word were not now in hostage to slang, one would want to describe the view here as awesome.

The wilderness that some of the Group of Seven artists painted in the years just after the First World War was already beginning to disappear. (It is worth remembering that in 1929 the painters George Reid and his wife Mary were invited by Ontario's Minister of Natural Resources to spend some time in the summer sketching in the Abitibi Canyon south of James Bay. A pulp-and-paper company was building a dam there, and he wanted them to record the canyon before it disappeared in the general flooding.) There are, as has often been remarked, no figures in the northern landscape paintings of the Group of Seven. That absence, however, is so intimate a part of their vision of the country that it is foolish to berate them for it. An inextricable element of the modernist aesthetic in all of the arts was a criticism, often voiced but sometimes implicit, of the idea of progress and development, a theme dear to the heart of Victorian England and the Empire. The war put an end to the nineteenth-century notion that human history had been a slow and stately progression from barbarity to civilization, and it is surely no coincidence of chronology that some of the most famous images produced by the Group of Seven were painted in the immediate aftermath of the European war, in reaction almost. This was Canada, some of the paintings seemed to say, before civilization began or *homo sapiens* even showed his face. "We have been driven towards perfection by the suffering of the war," was how MacDonald put it in his 1919 article "The Canadian Spirit in Art."

In a review of the fourth Group of Seven show in the *Canadian Bookman*, Bess Housser wrote: "Canada is an entity with a spiritual form drawn from the significant character of her environment." Such a statement, so characteristic of art talk in the Toronto of the 1920s, applies beautifully to MacDonald's *The Solemn Land*. The Edenic quality of the landscape is striking, even if it is a particularly northern vision of paradise; and it is hard not to think that, tramping about the uninhabited Algoma region, MacDonald and his fellow campers must have indulged a little in the fantasy

that they were really the first humans to see the country. (Herman Voaden used the painting among other Group of Seven pictures to illustrate *Six Canadian Plays*, a collection he edited in 1930, and wrote of it as evoking "the silence of a virgin land of hills and forests.") All the same, and as intuitive and poetic as his sensibility was, MacDonald was a brilliant and highly trained designer; however undisturbed and wild the country he was painting may have been, its rendering on canvas was carefully composed. The composition is certainly not so formal as an older generation artist might have made it. George Reid's *Agawa Canyon* (1926) or Homer Watson's *The River Drivers* (1914), for example, bear certain similarities of subject matter to the MacDonald painting, but are far more conventionally planned, not to say more conventionally painted. The secret of *The Solemn Land*, however, lies in part in the masterly balance MacDonald has achieved between design and spiritual tone.

It is instructive to compare *The Solemn Land* to MacDonald's later mountain paintings. After the Algoma period (1918-22) he spent most of the remainder of his life doing paintings based on sketches made during annual autumn trips to the Rockies. Many writers have been rather condescending about these pictures. A.Y. Jackson thought that they "lacked ... vigour." The art historian William Colgate dismissed them as "rather too suggestive of the sort of thing transportation companies affect to be altogether satisfying." Barker Fairley, a friend and supporter of the Group, had misgivings about MacDonald's first western canvases, and Bess Housser, in the review already cited, passed over them rather hastily: "J.E.H. MacDonald has found in the mountains a playground for his great feeling for design. There his real interest seems to have stopped and the colour has the effect of being filled in." In principle a painting of the British Columbia mountains ought to be able to inspire the same emotions of grandeur and quietude as are evoked by *The Solemn Land*. Surely there is nothing more prototypically Canadian about the northern Ontario forest than about the western mountains? The Algoma picture is far from being free of the lyrical stylization in the art-nouveau manner which MacDonald inherited as a designer; look, for example, at the shape in the lower left-hand corner of the canvas.

Yet a western painting like *Goat Range, Rocky Mountains* (1932), as fine a picture as it is in some ways, falls short of embodying spiritual awe by too rigorously balancing the remote peaks in the background against the detailed rock formations in the foreground. The design element, which MacDonald once described as "perhaps not so much a component part, as the element in which art lives and moves and has its being," works here to distance the viewer from the landscape.

Like the modernist poets who were their contemporaries, the Group of Seven talked a good deal about discarding inherited form and the conventional subject matter of Europe. A new technique, they contended, was needed to deal with a hitherto unpainted landscape in a new spirit. A poet such as W.W.E. Ross provides an illuminating parallel. Not only did he visit the North – he was part of a surveying team that travelled by canoe to the country above Lake Superior near Algoma in 1912 and 1913 – but as a poet he attempted to invent a new form to deal with his northern experiences, a form, as he put it, "that would be 'native' and yet not 'free verse.'" The group of pieces that emerged later from these ideas and experiences he called *laconics,* and it is interesting to note that, in his words, they "were written in Toronto after a lively evening's discussion of Canadian nationalism." Ross's work was fresh and innovative in the context of the Canadian poetry of the time, but its technical roots lay pretty much entirely in the metrical and formal experimentation of Anglo-American modernism. Similarly, the technical and formal aspects of the Group of Seven's work were not nearly so innovative as the painters and their critics thought. MacDonald's sources were primarily European. One can detect the Barbizon influence as late as *Harvest Evening* (1917), and the characteristic tropes of art nouveau pervade his work.

Iconographically the situation is different, and here MacDonald's originality and that of other members of the Group of Seven is more in evidence. It is difficult to imagine any of his Canadian predecessors treating a subject like *Leaves in the Brook* (1919), with its wonderfully lyrical, tapestry-like rendering of a small scene that seems to lie at the viewer's very feet. The picture is far from formless (the brook runs by

design from the upper left to the lower right corner), but its feeling is one of freedom, freshness, and a delight in colour. A later Algoma picture like *Rowanberries, Algoma* (1922), although not so exuberant, is equally original. These pictures and others prove the justness of applying to MacDonald himself an observation he made about the Scandinavian painters whose work he and Lawren Harris saw in Buffalo in 1913. Those artists, he said, "seemed to be a lot of men not trying to *express themselves* so much as trying to express something that took hold of *themselves*." The distinction is a crucial one, for in it rests the defence against many of the charges of art for art's sake, limitless subjectivity, and formlessness that were laid at the Group's door. Self-expression is of course the lowest form of making art. However civilized into elegance and convention it may get, it is never far from its roots in psychopathology. This is exactly the opposite of what MacDonald and his associates wanted to embody in their art.

Art in the service of nationalism is almost unfailingly shallow and unenduring. Canada had proved itself as a nation state in the war, and in the decade that followed there was a considerable amount of nationalist sentiment loose in the land. However serious and important its political expression was (it finally led in 1931 to the Statute of Westminster), Canadianism, in the arts, had very mixed results. The modernist poets tended to make fun of the Canadian Authors Association and its take-a-Canadian-writer-to-lunch mentality, a point of view pilloried in F.R. Scott's well-known poem "The Canadian Authors Meet," written in 1927. The English-born MacDonald (three members of the Group of Seven were born in England within a hundred miles of one another) had undeniably strong feelings about his adopted homeland; "The Canadian Spirit in Art," published on the eve of the Group's formation, is a paean to "this vast variety" which is Canada.

Perhaps nationalist emotions are bad for art because they are so generalized in ideas of race, achievement, space, language, and other quite unspecific notions. Good art is rooted in the particular. The epigraph to *West By East*, MacDonald's posthumous collection of poems, puts it succinctly: "The Universal Soul," goes the

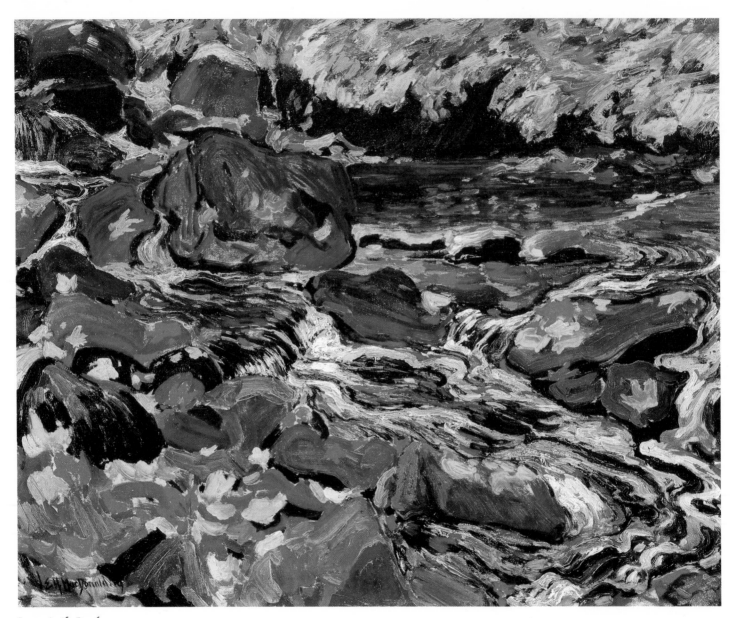

Leaves in the Brook

line from Henry David Thoreau, one of MacDonald's favourite authors, "has an interest in the stacking of hay and the foddering of cattle." A devotion to the particular kept the Group from indulging in any art even remotely allegorical, at least in the early years. Their best work does not simply illustrate an emotion or carry a literary or historical narrative – it bodies forth some of the unique and characteristic landscapes of Canada, "to show / Beauty of the plain / Things we know," as MacDonald expressed it aptly in his poem "Sunset."

MacDonald's lack of interest in abstract art is explained by this emphasis on the individuality of the perceived world. In a 1929 lecture he referred to the "modern tendency [in painting] ... to shun all *poetic* feeling, in a search for a cold geometry of pattern, a leaden quality of volume, & a mystery of significant form." He disliked Cezanne and reacted so scathingly to Bertram Brooker's January 1927 Arts and Letters Club exhibition (the first public exhibition of abstract art in Canada) that he felt compelled to write Brooker a letter of apology. His wonderful oil sketches occasionally achieve an almost non-representational quality (*Lake Simcoe* of 1921 is a good example) and from the very first, the representational qualities in his painting were never precise or photographic. What he called "poetic feeling" in the 1929 lecture on poetry and painting is his essential characteristic: the ability to balance the visual in all its particularity with a highly original painterly sensibility. In that unspoken strategy lies the poetics of MacDonald's art.

The Early Years

FROM THE STRAY REMARKS and scattered reminiscences of his friends and contemporaries, J.E.H. MacDonald appears the very quintessence of what we think of as an artist. Arthur Lismer, a fellow member of the Group of Seven who worked for MacDonald at Grip Printing & Publishing Co. in 1911, described him as a "secular monk" who had "something of [the] simple mysticism" of St Francis. Barker Fairley, the Sunday poet and painter who was an associate of and proselytizer for the Group, remarked that there was "something of the quietist" about MacDonald, and others commented on his poetic sensibility, his unrobust inwardness, his "retiring temperament." His son, Thoreau MacDonald, himself an important artist, thought his "strongest characteristics were his sense of justice and humor," and more than thirty years after his father's death he still recalled MacDonald's "lonely feeling," his "essential loneliness."

A serious and reflective person he was, then, but also one with a keen wit and sense of fun. A student at the Ontario College of Art, where MacDonald was the new head at the time, remarked in 1929 on "a precious gleam of merriment in the eyes of this, our lanky principal." A.Y. Jackson recounted an anecdote involving Napier Moore, the editor of *Maclean's*, who was complaining about *Chatelaine*, then a new magazine, and the taxing effect its success was having on the company's printing plant. When he wondered aloud how he might cut the magazine's circulation, MacDonald replied: "That's easy, Napier, just improve the quality." A minute from a 1928 staff meeting at the Ontario College of Art, when Principal George Reid was on leave and MacDonald was acting in his place, recorded a longstanding battle with student lateness, long lunches, smoking in forbidden places, and so on, and concludes

with the resolution that MacDonald "should address a gathering of the students in exhortation and reproof," the last a tongue-in-cheek phrase surely MacDonald's own. He was a popular instructor, and overwhelmingly the choice of the student body to replace Reid when the latter left permanently at the end of the 1928-29 teaching year.

He was tall with a full head of curly red hair, and although not perhaps so devoted to physical culture as some of his painter friends, he seems to have been clever with his hands and reasonably at home in the woods. A physical breakdown in 1917 and his early death at fifty-nine have perhaps helped to create the misapprehension that MacDonald suffered lifelong frail health. A.Y. Jackson contributed to this picture of him as a "quiet, unadventurous person" in his autobiography, where he claimed that MacDonald "could not swim, or paddle, or swing an axe, or find his way in the bush." This was, at least according to Thoreau MacDonald, a great exaggeration based on the fact that Jackson and MacDonald were first in the bush together during a trip to the Algoma country in 1919, when MacDonald was still feeling the effects of his stroke of almost two years before, and was doubtless trying to take it easy. "I resented [this story]," Thoreau confided to a notebook in 1956, "as I knew that when my father was well he was far more capable than Jackson in the use of his hands & in all practical work, using tools etc. He made nearly all his big frames, 48 x 60" & did lots of carpenter work around the house." Thoreau also noted that among his earliest memories was watching his father cut down trees on the property of their first house on Quebec Avenue, in the High Park area of Toronto.

James Edward Hervey MacDonald was born on May 12, 1873, near Durham, England, of a Canadian father and an English mother. His early years were spent in Kirkby Stephen, a small town then in Westmorland County at the very eastern end of the Lake District some 268 miles northwest of London. Hills to the north and south of the town separated it from Yorkshire, where Arthur Lismer and Frederick H. Varley, two of MacDonald's Group of Seven associates, were born. In MacDonald's childhood, Kirkby Stephen was probably still much as Samuel Lewis had described it in his *Topographical Dictionary of England* in 1831: "it consists of one good street, the

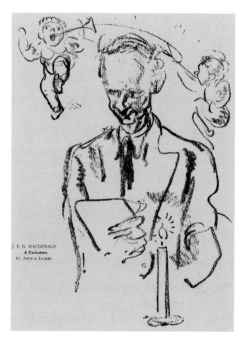

Caricature of J.E.H. MacDonald
by Arthur Lismer

houses in which are well built, and the inhabitants abundantly supplied with water; but the town is neither paved nor lighted." There was a fine church (St Stephen's) and a school (dating to Elizabethan times), which MacDonald may have attended.

MacDonald's paternal ancestors had gone to Quebec as Loyalists to the Crown after the American Revolution, and it was on a visit to Durham that his father met and married MacDonald's mother. In 1887, William H. MacDonald decided to take his family back to Canada. They settled initially in Hamilton, Ontario, where MacDonald senior worked as a cabinetmaker and where they lived in a house on Picton Street East. At fourteen, J.E.H. MacDonald (later Jim, or Jimmy, or Mac to friends) went to work at a local lithographing company, training which would long stand him in good stead both as a graphic designer and as a painter. By the late 1880s, lithography was almost a century old but still the cheapest and most widespread technique for reproducing images. There were four commercial lithography houses in Hamilton in 1887, and it is not known in which the teenaged MacDonald apprenticed, but it may have been the Duncan Lithographic Co., which was the only one left by the time of the 1889-90 city directory. The fact that the 1890-91 directory lists no lithographic companies at all may account for MacDonald's move with his family to Toronto at that time.

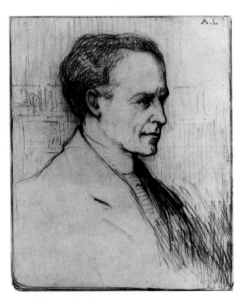

Portrait of J.E.H. MacDonald
by Arthur Lismer

MacDonald arrived in Hamilton just one year after the founding of the Hamilton Art School which, with the Central Ontario School of Art and Design, later the Ontario College of Art, was one of only two art schools in the province. (The Hamilton school disappeared as an independent institution in 1909, when it was merged with the local board of education). MacDonald took classes there during his spare time; Arthur Heming, later well-known as a painter and book illustrator as well as as a writer, was probably one of his teachers. Heming's fascination with "the primitive spirit" and "daydreams of the Northland," as he phrased it in his book *The Drama of the Forests* (1921), may have piqued MacDonald's own interest in the northern landscape.

After moving to Toronto in the early 1890s, MacDonald worked first for the Toronto Lithographing Co. and then spent a year or so at C.E. Preston & Co., a

Oaks, October Morning

competing firm, before moving in 1894 to the Grip Printing & Publishing Co. on Yonge Street, the commercial art and design firm where five members of the future Group of Seven worked for varying lengths of time. Only A.Y. Jackson (who came from Quebec) and Lawren Harris (who possessed independent means) did not work at Grip. The company took its name from the raven in Charles Dickens's novel *Barnaby Rudge*, the founder, J.W. Bengough, having borrowed the bird as the logo of his comic newspaper *Grip*, which he started in 1873. Looking back in the early 1920s on the commercial work done in Toronto in the 1890s and the first part of the twentieth century, MacDonald remarked that the "difficulty of the artist or designer was in doing work *bad* enough to please his customer." That time was, he said, the "trying stage in the development of Toronto when good work was almost prohibited by law, when they built Victoria College for instance."

MacDonald's first period of employment at Grip lasted for a decade, from 1894 to 1903, and it can be assumed that his skill as a designer began to develop during those years. Peter Mellen describes the Grip workshop as practising "a late form of European *Art Nouveau*," and certainly the influence of that style is still marked in MacDonald's book designs of the 1920s and even in the late Rocky Mountain paintings. During this time he was also a member of several artists' clubs, through which he met many Toronto area artists and was able to hone his drawing and painting skills. The most important among these associations was the Toronto Art Students' League (1886-1904), organized to provide artists with a regular opportunity to draw from a model and to arrange sketching expeditions in the environs of the city. A painting from 1891 entitled *At Work in the League* by William Bengough (one of J.W.'s brothers) shows some two dozen members of the League sketching a piper in full regalia in the club's rooms on Wellington Street. MacDonald surely took advantage of this sort of opportunity with great eagerness.

The most lasting achievement of the Toronto Art Students' League was its series of annual calendars, where the work of important members like C.W. Jefferys, David F.

Thomson, A.H. Howard, and R. Weir Crouch was reproduced. The design of the last two in particular must have influenced MacDonald at this time. In a 1931 lecture on "The Art of the Book," given at the Art Gallery of Toronto, he singled out for praise Howards's decorations in Duncan Campbell Scott's poetry collection *Via Borealis* (1906), and his only contributions to the calendars, the February and April pages in the 1904 issue, are reminiscent of the work of these two older contemporaries. His earliest known book design, an illuminated text called *A Word To Us All*, which he executed in 1900 (the original has disappeared, but it was reproduced as the Ryerson Press Christmas card in 1945), shows the same influences crossbred with that of William Morris and the Arts and Crafts aesthetic. Over twenty years later, he would still caution students "to do what we can to uphold Morris' standards and ideals."

Around the turn of the century MacDonald belonged to three other artists' associations: the Mahlstick Club, the Little Billie Sketch Club (which took its name from the main male character in *Trilby*, George Du Maurier's 1894 novel about an artist's model in Paris, which had a vogue at the time), and the Graphic Arts Club. Surviving watercolours from the late 1890s show him to have been at this stage a rather conventional but highly competent painter, already something of a "forest specialist," as he described himself in 1906 in a letter to his wife. As he had in Hamilton, in Toronto he continued to study in his off hours, and George Reid, for whom he later worked at the Ontario College of Art, was one of his teachers. Reid was a superbly trained painter whose emphasis on Canadian subjects, not so common among Canadian artists in those days, obviously impressed MacDonald. He would remember Reid as one of the "pioneers & encouragers" in a now famous letter to F.B. Housser, written in response to Housser's book about the Group of Seven, *A Canadian Art Movement* (1926).

On his twenty-sixth birthday – May 12, 1899 – MacDonald married Joan Lavis, a McMaster University student. (McMaster at that time was located in Toronto, in the present Royal Conservatory of Music building on Bloor Street West, and did not move to Hamilton until 1930.) The MacDonalds set up in a small house on Quebec Avenue

near High Park in what was then called Toronto Junction. A son, Thoreau, born in 1901, would be their only child. Shortly after his marriage, MacDonald was tempted to join the Roycrofters, the intentional community Elbert Hubbard had founded in imitation (sometimes pale) of Morris's Arts and Crafts philosophy. In 1900, he and Joan MacDonald visited the Roycroft shop in East Aurora, New York, near Buffalo. It was presumably the design ideals and printing activities he saw there that attracted MacDonald, although in the end he decided not to join Hubbard's movement.

Instead he went much further afield. Three of his friends in the Toronto Art Students' League – A.A. Martin, W.T. Wallace, and Norman Price – had gone to England, where, with A.A. Turbayne, an American-born designer, they founded the Carlton Studio in Fleet Street. The firm provided design and illustrative services to the book trade, and on the principals' invitation to work for them, MacDonald departed Canada in December 1903, leaving his wife and son behind. After a year of sharing rooms with Norman Price, he returned to Toronto to take Joan and Thoreau back to London, where the family remained until 1907. Relatively little is known about MacDonald's work at the Carlton Studio. The Carlton Studio regularly signed its bindings with a "CS" monogram, not with the initials of individual designers. But the fact that the binding design on H. Lawrence Swinburne's 1907 book *The Royal Navy* is certainly his (it was later reproduced in a Shaw Correspondence School syllabus as an example of his work) suggests that MacDonald designed many other bindings as well. This was assuredly more congenial employment to him than his usual work at Grip, where he had designed patent medicine labels and the like.

Turbayne, for whom MacDonald worked at Carlton, was a master letterer and designer, and the Canadian artist must have learned a great deal from him. The titling on *The Royal Navy* uses one of the alphabets from Turbayne's *Alphabets & Numerals* (1904), a stunning model book which MacDonald no doubt owned and studied closely. More generally he took advantage of his London years both to look at art and to improve his painting. He wrote to his wife about visits to the Victoria and Albert Museum and the Tate Gallery, and was particularly struck once by "a

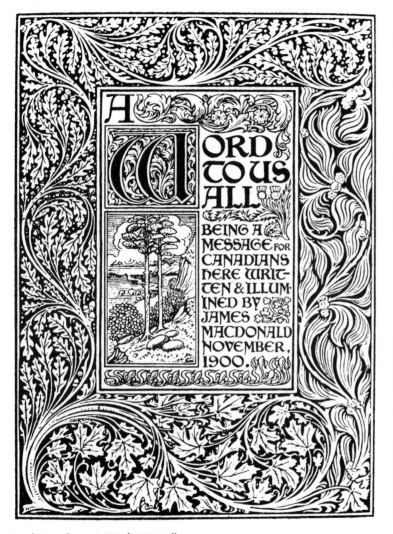

Book Page from *A Word To Us All*

Binding Design for *The Royal Navy*

little forest picture" by Virgile Narcisse Diaz de la Peña, one of the Barbizon painters. From the Diaz picture, he confided, "I seemed to get a clear feeling, though faint and far off, that someday I, too, would be an *artist* and produce similar things." The Barbizon devotion to *plein-air* painting would have struck a chord with MacDonald and reminded him vividly of his own sketching trips round Toronto. The work of the English landscape painter John Constable, whom MacDonald later reverenced as "a great vital, varied nature," also attracted his admiration, and many a skyscape in later MacDonald paintings owes a discernible debt to Constable's work.

As the Canadian art critic Paul Duval has pointed out, MacDonald was a late bloomer as a painter, by inclination (perhaps) and by force of circumstances. When he returned to Toronto at the end of 1907 he was thirty-four years old; and although he was an accomplished designer and letterer by then, he was only at the beginning of a career as a painter. His first exhibited work, a painting called *Winter Moonlight*, was shown at the 1908 Ontario Society of Artists exhibition and led to his being elected to the OSA the following year. He had more canvases in the 1910 show, and it is clear that his confidence was growing in these early years following the return from England.

The founding of the Arts and Letters Club in 1908 was to play an essential role in MacDonald's increasingly rapid development during that period. On his return to Canada, he had gone back to Grip as head designer, and the team there often met for lunch at the club, where musicians, writers, and artists, as well as people only loosely involved with the arts would congregate. The Grip team eventually included Tom Thomson (hired in 1907), Arthur Lismer and Franklin Carmichael (both hired in 1911), and more briefly Franz Johnston (1908) and Frederick H. Varley (who worked for the company for only three weeks in 1912 before following several other defecting employees to Rous & Mann, a rival firm). A.H. Robson was the art director who kept his crew of individualistic designers in order ("I'm not running an art school," he would complain goodnaturedly). Leonard Russell's often cited description of MacDonald at Grip is worth quoting again:

At one end of the room sat Jimmy MacDonald, as he was then familiarly known. His desk was covered with sketches, notebooks, paints and brushes, all in utter confusion. It was said that, when he left Grip, he found on his desk material which had been missing for years. I cannot vouch for this, but I do know that his table seemed always full and he did his work on one corner. He was a great reader and always had a book on hand to take up in any spare time he had. ... Although quiet and reserved, he possessed a Scottish sense of humour, was kindly disposed and always willing to help, with keen criticism, any of the younger artists.

(MacDonald presumably had something of a North Country accent which, together with his surname, sometimes misled people into assuming that he was a Scot.)

Augustus Bridle, the author of *The Story of the Club* (1945), wrote that, for MacDonald, "the Club was a brotherhood for discovery of more life worth while to live," and MacDonald certainly played an intimate part in the club's activities. He designed its bookplate and coat of arms, served as president from 1928 to 1930, delivered lectures there, and took part in many theatricals and other events. Most importantly of all, he held his first one-person show there, in November 1911, a few months after his election.

That year was a crucial one in MacDonald's life and career. He exhibited at the annual spring show of the Ontario Society of Artists; in that same exhibition, A.Y. Jackson contributed a canvas entitled *Edge of the Maple Wood* which impressed Lawren Harris deeply and which he later arranged to buy through MacDonald. Several of the future Group painters were dazzled by this painting, which Jackson had done in rural Quebec close on his return from a sojourn in France. Their interest in it had the double effect of opening their eyes to the possibilities of applying Impressionist techniques to the Canadian landscape and of bringing Jackson himself to Toronto in 1913, where he met Harris, Lismer, Thomson, and MacDonald himself.

But the high point of 1911 was MacDonald's Arts and Letters Club show, in which he exhibited a series of oil sketches executed in High Park and along the Humber River. These sketches embodied a nascent maturity and what C.W. Jefferys,

in a review of the exhibit, called "a refreshing absence of Europe, or anything else, save Canada and J.E.H. MacDonald and what they have to say." Like Jefferys, Lawren Harris was struck forcefully by the sketches: as he recalled in 1948, they contained "an undefineable spirit which seemed to express the country more clearly than any painting I had yet seen." MacDonald's work, he concluded, "affected me more than any painting I had ever seen in Europe." Thus the Arts and Letters Club show, for the first time, led to MacDonald's name being linked with a particularly Canadian subject matter and technique. His various influences were at the point of being forged into an individual approach, one with the philosophical mission of embodying the local landscape in paint. As he would remark a decade later in one of his OCA lectures, "let us look on ourselves as *Early Canadians*, here in good time, in a fresh country, with its art expression practically just begun."

The most immediate result of the 1911 exhibition was MacDonald's decision to resign from Grip and become a freelancer, in order to have more time to paint. In this brave and risky change of life (he was, after all, supporting a family, and the market for his sketches and easel paintings must have seemed almost non-existent) he was encouraged by Lawren Harris and Dr James MacCallum, a Toronto ophthalmologist whose patronage of Tom Thomson, A.Y. Jackson, and other younger painters was of far-reaching importance. From our vantage, we can see that MacDonald was poised in late 1911 on the brink of a remarkable decade in which he would accomplish much of his major work and link his name permanently with the avant-garde in Canadian painting. Yet he can have had only the vaguest inkling of any of this. In 1911, he still knew little about the Canadian landscape; he had been to Nova Scotia with his friend Lewis Smith in the 1890s, but was otherwise relatively unfamiliar with any area save southern Ontario around Toronto. But an early oil like A *March Evening* (1911) demonstrates both the design skill already singled out by Jefferys and his clear and affectionate eye for the land and weather. In leaving a full-time job at thirty-eight he must have felt uneasy but prospective. He might already have been envisaging, as Jackson put it in his autobiography, "a school of painting in Canada that would realize the wealth of motifs we had all around us."

Many Canadian artists are handicapped by having to devote the greater part of their time to work apart from art, and men of great talent have been discouraged by the indifferent prospects of artists, and the slight esteem in which artists are held.
J.E.H. MacDONALD

THE YEARS leading up to the outbreak of the First World War were remarkably fertile ones in the development of Canada's imaginative life. Sir Wilfrid Laurier's famously inaccurate prediction that the twentieth century would belong to Canada may seem eccentric from our perspective. In 1929, Arthur Lismer would echo Laurier's prediction in his overly optimistic statement that "the twentieth century, in Art, is Canada's, and the signs are hopeful." But in the ten-year period between Laurier's aphorism and the outbreak of fighting, there was much taking place artistically to support the idea. Eric Brown, who would be a great supporter of the Group, was appointed director of the National Gallery of Canada. New publishing houses like McClelland & Goodchild, McLeod & Allen, and the Macmillan Company of Canada were beginning to contribute to a quickening renaissance in Canadian literature. Arthur Stringer's *Open Water* appeared in 1914, the book of poems in which a rationale for *vers libre* is first deliberately argued by a Canadian poet. *The Year Book of Canadian Art*, on whose publication committee J.E.H. MacDonald served, was issued by J.M. Dent & Sons with the editorial support of the Arts and Letters Club. Out of the ruins of the old Central Ontario School of Art and Design came the Ontario College of Art, incorporated in 1912 and "much better organized, better equipped, and better supported," as the painter Charles M. Manly described it in the *Year Book*. Every member of the Group of Seven except Lawren Harris later taught there.

In the development of a distinct tradition of Canadian painting and in the life of J.E.H. MacDonald, 1913 was an especially rich year. The OCA completed its first year and the Arts and Letters Club brought out its survey of the state of the arts in Canada.

The Free Years

CHAPTER THREE

(Despite his role in assembling the book, MacDonald was not spared a blow or two in its pages. Fergus Kyle, in reviewing the 1913 Ontario Society of Artists show, mentioned him and Harris as "two of the younger men whose work is outstanding." But his large canvas *Fine Weather, Georgian Bay* was dismissed as having "nothing remarkable in composition" and ambiguously described as a picture of "colour, mood and the feeling of charity – and ozone.") The Studio Building, built with money provided by Lawren Harris and Dr MacCallum, opened at 25 Severn Street in the ravine near Rosedale, and immediately became an important meeting place for progressive artists. That same year, MacDonald and his family moved to Thornhill, in the countryside north of the city, so that a space in the Studio Building was particularly valuable to him for keeping him in touch with friends and the Toronto art scene. A.Y. Jackson, who went to Toronto in that same year, took over MacDonald's studio much later and admired uncomprehendingly the favourite MacDonald quotation lettered at the base of a room: "With the breath of the four seasons in one's breast one can create on paper. The five colours well applied enlighten the world." MacDonald often cited this Chinese proverb to his students. And finally, 1913 was the year that Harris and MacDonald made a point of seeing a Scandinavian art exhibition in Buffalo which gave them renewed impetus as Canadian landscape painters.

To call the decade in MacDonald's life from his resignation from Grip following his first solo show until he began working as an instructor at OCA in the fall of 1921 his "free years" is to be slightly optimistic, perhaps even inaccurate. Although free of full-time employment, he was still responsible for the support of himself and his family. Like freelancers before and since, he pieced together an income from a multitude of sources, rather like the tesserae that make up a mosaic. He did some marking for the Shaw Correspondence Schools. He designed window displays for Simpsons department store and worked as a designer for the Canadian National Exhibition. He was commissioned to execute covers for *Canadian Magazine*, *Sailor*, and other Toronto periodicals, and did design or illustrative work for publishers, including, for example, a cover vignette for Alan Sullivan's I *Believe That* (1912) and the illustrations in Roy

Mitchell's *Shakespeare for Community Players* (1919). He designed bookplates and apparently continued a freelance relationship with Grip which must have resulted in various sorts of commercial work now lost or yet to be recognized as MacDonald's. He was free in a sense, but hardly carefree.

The release from daily work certainly had an effect on MacDonald's productivity which, though never torrential, now increased significantly. In the mid-1950s, Thoreau MacDonald made an informal graph of his father's output. It shows a constant and significant climb from 1912 until his illness in 1917, when there is a break; after his recovery, he resumed his old pace and maintained it until he started teaching full-time in 1921.

In 1912, as though to mark his entrance into a fuller life as an artist, MacDonald produced one of his first masterpieces, an oil painting entitled *Tracks and Traffic* on an unusual theme for him. The picture, which was exhibited among six of his canvases at the 1912 OSA exhibition and later reproduced in the important magazine, *Studio*, depicts a piece of the industrial landscape near the Toronto harbour; a railway engine provides the mid-ground focal point, although the overall composition is dominated by large areas of white and grey paint representing snow, steam, and smoke. Two small figures ambling along a wooden sidewalk appear in the lower right corner, but are dwarfed by the factories and freight yard whose rectangular shapes are the real basis of the composition. The steam and smoke which compose the skyscape are a variation on MacDonald's lifelong attraction to cloudy skies. *Tracks and Traffic* is a studio painting worked up from sketches, and its existence owes more than a little to Lawren Harris's interest in sketching the tatterdemalion districts of Toronto. Like some of his other pictures from this time, this one borrows substantially from Impressionist concerns and techniques, and an evident parallel can and has been drawn between it and Claude Monet's Paris train station paintings of the 1870s.

MacDonald never returned to the uncharacteristic subject matter of *Tracks and Traffic*. Perhaps he felt that his imaginative apprehension of the world was better suited to realizing the natural world where humankind had not yet left traces. "I am

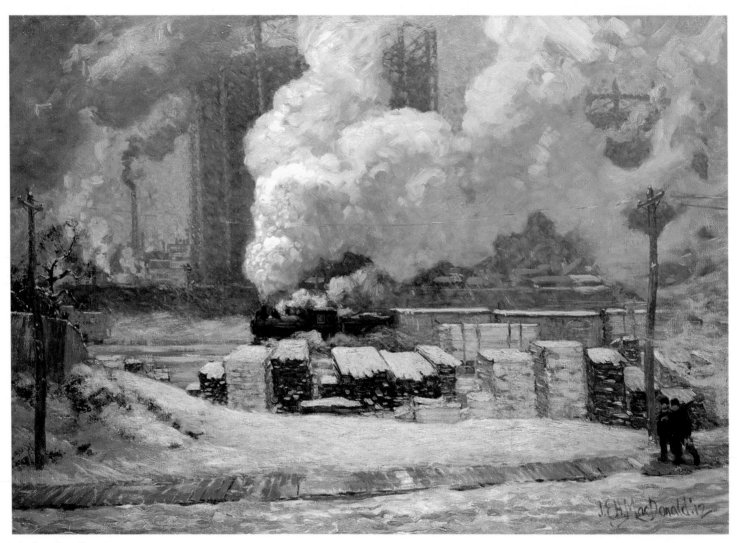

Tracks and Traffic

afraid," he remarked in a lecture on design, "I have an impressionistic kind of mind that tends to blur the edges." That mind was perfectly capable of dealing with urban scenes and with figures (the illustrations in *Shakespeare for Community Players* demonstrate his skill at figure drawing), but evidently he was not very interested in doing so. Figures occur rarely in his work, and when they do they are almost without exception drawn very small. *Tracks and Traffic* is a real achievement, then, but a somewhat eccentric one in terms of MacDonald's work as a whole.

The year 1913 began with a visit in January to the Albright Gallery in Harris's company to see an exhibition of Scandinavian art, an outing which was to have far-reaching consequences on MacDonald's art and which A.Y. Jackson would later characterize as "a starting point for the Group of Seven." MacDonald left a crucial record of his response to this exhibition in a public lecture he gave at the Art Gallery of Toronto on April 17, 1931. His text makes clear that inchoate ideas about what he wanted to do as an artist were partly crystallized during and after his trip to Buffalo. The parallel between the Nordic landscape and Canada came home to him forcefully, and he remarked at the outset of the lecture how he and Harris "had feelings of height and breadth and depth and colour and sunshine and solemnity and new wonder about our own country, and we were pretty pleased to find a correspondence with these feelings of ours, not only in the general attitude of the Scandinavian artists, but also in the natural aspects of their countries." His reaction in a nutshell, as he put it, was, "This is what we want to do with Canada."

In these first years of relative freedom from regular employment, MacDonald came to know parts of the country he had not much seen before. Summers were spent at a cottage at Burk's Falls, Ontario, in the Muskoka district, and in 1912 he made his first visit to Dr MacCallum's cottage near Go Home Bay. In the fall of 1913, he went on a trip to the Laurentians in Quebec, again with Lawren Harris, and in spring 1914 he sketched in Algonquin Park with A.Y. Jackson and another painter friend, J.W. Beatty. With the Scandinavian example in his mind, these expeditions produced the beginnings of what we tend to think of as the characteristic northern

canvases with which the Group of Seven and Tom Thomson are linked. Some of the iconic masterpieces of that northern landscape painting came later, after trips to the country northeast of Lake Superior, but paintings like The Lonely North and A Rapid in the North, both from 1913, or March Evening, Northland from 1914 (one of the Algonquin works) embody the beginnings of MacDonald's deep response to what the poet Ralph Gustafson once called the New World Northern.

MacDonald thought a good deal about the relationship between the artist and the critic. In 1918, he published an essay on the subject entitled "The Terrier and the China Dog" in the Rebel, in which he stated severely, "Art is the growing flower, Criticism the dried plant pressed flat in the leaves of books." Elsewhere he dismissed with undisguised distaste "the frosty condescensions of super critics on volumes or dimensions, and other art paraphernalia." In gently chastising F.B. Housser for some of the inaccuracies in A Canadian Art Movement, MacDonald suggested that "things should be reflected as they were & not as they appear in the light of Cezanne or Roger Fry." (Housser was an amateur and an enthusiast, not a professional critic or art historian.) MacDonald's polemical dismissal of most of what then passed for art criticism was no doubt partly a reaction to some of the attacks he and his associates suffered as their work became more experimental.

The earliest of the vitriol-slingers was Harry Gadsby, whose infamous "Hot Mush School" piece in the Toronto Daily Star on December 12, 1913, was ostensibly a review of an Arts and Letters Club exhibition of Jackson sketches. It was sarcastic and dismissive of the new painting, which was described as "more like a gurgle or a gob of porridge than a work of art," and it galvanized MacDonald into a rebuttal which constituted his first public defence of the younger Toronto painters. The pictures ridiculed by Gadsby, he wrote, were "a product of Vitality and not Decay," and he asked for support of "our distinctive Native art, if only for the sake of experiment." His use of the word experiment here is interesting as an early instance in Canada of the classically modernist equation of art and experimentation. Twenty-five years ago, Peter Mellen debunked the myth that the painters who became the

Group of Seven received nothing but abuse from the critics. Nevertheless, distinctly negative criticism like Gadsby's did occur often, although it may in fact have had a positive effect on the painters by uniting them in opposition.

The years 1915-16 were vital and important ones for MacDonald. He received a commission from Dr MacCallum for decorative panels at the cottage MacCallum had built on a Georgian Bay island in 1911. MacDonald shared the assignment with Lismer and Thomson. He visited the cottage in the autumn of 1915 and made notes and sketches in a sketchbook, on the basis of which he painted his sections of the job in his studio the following winter. The full twenty-three panels, of which twelve were by MacDonald (or ten, if one counts the *Inhabitants of Go Home Bay* as two rather than four), were installed the next spring.

The MacCallum-Jackman cottage mural paintings, as they are now officially called, are unique in MacDonald's *oeuvre*. He would do some other building decoration in the 1920s on a more limited scale; but here one can see brought together a number of his characteristic and varied strengths as a designer and painter. The six smaller decorative panels, all roughly two feet by three feet and designed to fit above the windows, comprise a two-dimensional and heavily stylized set of variations on tree motifs. The trees depicted can all be found on Dr MacCallum's island, but MacDonald has somewhat abstracted and patterned them in the art-nouveau manner. The four remaining panels are more representational. The *Inhabitants of Go Home Bay*, a diptych installed on the two sides of the large stone fireplace, is unusual for MacDonald in being dominated by figures (for one of whom Tom Thomson served as a model). One perceives a witty edge to A.Y. *Jackson, Sketching*, which depicts a diminutive Jackson working in apparent obliviousness of the gathering storm clouds that fill almost half the pictorial space. *The Supply Boat*, the last and largest of MacDonald's paintings, beautifully balances the smallish human figures and the tall prow of the ship against the mass of grey rocks and the empyrean blue sky in a sort of Ontario cottage country version of pastoral.

In 1916, MacDonald also painted two of his best-known and most important

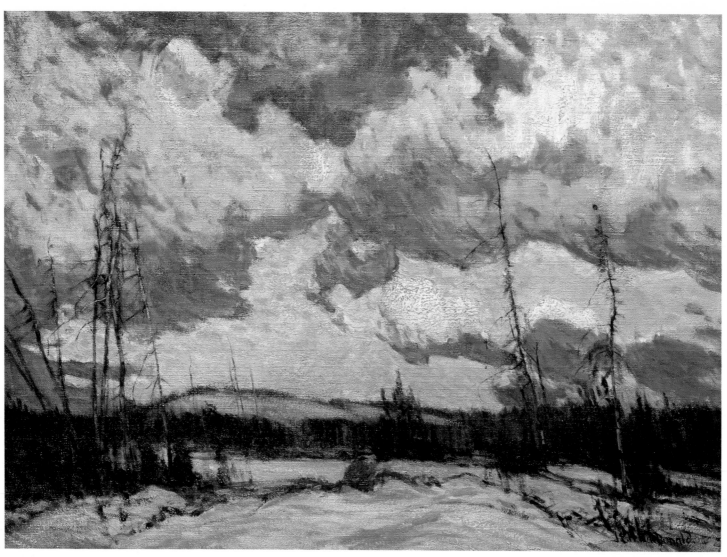

March Evening, Northland

canvases, *The Elements* and *The Tangled Garden*, which were among several he exhibited that spring at the central library as part of the OSA exhibition. As different in many ways as these paintings are, MacDonald avowed that they were "but items in a big idea, the spirit of our native land." *The Tangled Garden* was painted from sketches at MacDonald's place at Thornhill and is essentially a domestic picture, as the building in the background, which stretches almost the full width of the work, makes clear. There are no figures but one feels that they are somehow implied. The luxurious greenery in the lower half of the painting, however, pulls its spirit in the direction of an almost jungle-like wildness. The relative flatness of the pictorial space gives the picture a strong feeling of profuseness and rich colour, a kind of sensual indulgence. *The Elements*, by contrast, reflects the gloomy and hostile face of nature. The cruder brushstrokes and limited palette of this forceful work serve to emphasize its elemental theme. Two figures hunkered round a fire provide a focal point but are all but washed away by the wind and the threatening clouds. Nature in MacDonald's work is rarely as antithetical to human concerns as it is in *The Elements*.

E.R. Hunter, MacDonald's first biographer, called these paintings "the two masterpieces of [his] second period." Contradictorily enough, they elicited some of the harshest criticism to which he was ever subjected, including stentorian denunciations from the *Globe and Mail*, the Toronto *Daily Star*, and *Saturday Night*. (It is not enough in explanation to say that masterpieces are often reviled initially. A later work like *The Solemn Land* was sold immediately to the National Gallery and easily became a beloved icon of Canadian landscape painting. Neither *The Tangled Garden* nor *The Elements* sold during MacDonald's lifetime.) The *Daily Star* critic called *The Tangled Garden* "an incoherent mass of colour," while Hector Charlesworth in *Saturday Night* dismissed it as crude in colour and "too large for the relative importance of the subject." These and other criticisms came fast on the heels of published comments by the painter Carl Ahrens, who was a decade older than MacDonald and out of sympathy with the younger Toronto painters' work ("younger" being a relative term here, as MacDonald was forty-three in 1916). Ahrens dismissed MacDonald and his

associates as untrained amateurs, and proposed that they might do better to devote their creative efforts to "the destruction of the Hun."

As he had in 1913, MacDonald responded to his critics in a long letter-to-the-editor, this time in the *Globe*, which appeared on March 27, 1916. Again he emphasized the necessity for experimentation: "It would seem to be a fact that in a new country like ours, which is practically unexplored artistically, courageous experiment is not only legitimate but vital to the development of a living Canadian art." This aesthetic tenet, articulated here at an early point in the course of Canadian modernist art (art in the general sense), has had a remarkable half-life; well into the 1960s it can still be found among the articles of faith of poets and painters. Important poets of the 1920s like F.R. Scott and A.J.M. Smith applied the "new world/new form" proposition to their own work, and acknowledged the imagery of the Group of Seven as a source of inspiration. Scott's biographer cites these lines from "New Names" as a characteristic articulation of the creed espoused by MacDonald in his response to the "knockers":

Who would read old myths
By this lake
Where the wild duck paddle forth
At daybreak?

MacDonald produced several important paintings later in 1916 and in 1917, including *Wild Ducks*, *Asters and Apples* (another Thornhill garden picture), and *Harvest Evening*, a glowing late summer work on an unusual subject. But tragedy struck in July when Tom Thomson, by then an old and close friend, drowned in Canoe Lake. "I know how keenly you will feel his loss," A.Y. Jackson wrote from war-torn France. "You had very much in common. Tom I know though he was a man of very few words often expressed to me his confidence in you and in the future of your work. And without you he never would have associated himself with our little school."

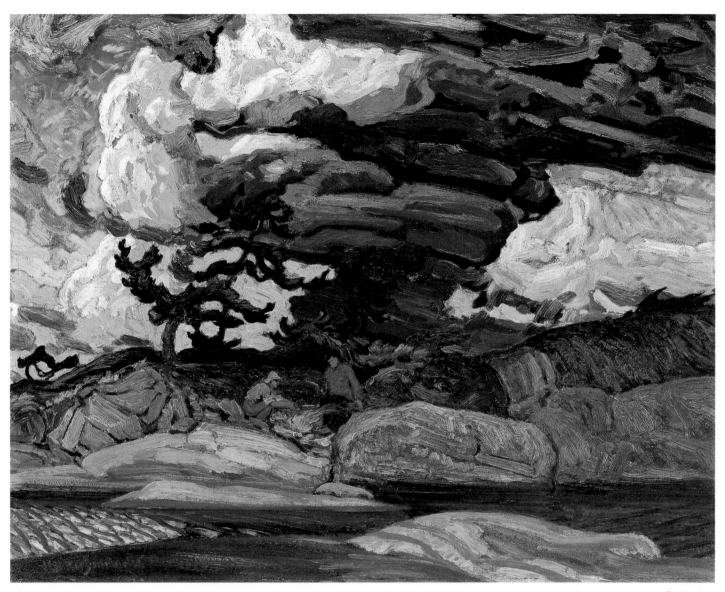

The Elements

MacDonald wrote and lettered a memorial for Thomson, which he and J.W. Beatty "set on the south face of a simple truncated pyramidal cairn of boulders, strongly piled and cemented in a commanding position close to an old camp of the artist" near Canoe Lake, as he described it in "A Landmark of Canadian Art," his composition of remembrance published in the November 1917 issue of the *Rebel*, a University of Toronto magazine, which metamorphosed into *Canadian Forum* in 1920. MacDonald designed the cover used on the *Rebel* during its last fourteen months, and was later a frequent contributor to the *Forum*, a journal instrumental in furthering the reputation of the Group of Seven throughout the 1920s. MacDonald joined the *Forum's* editorial board in 1923.

Thomson's death, together with "overwork and the strain of the war on a too sensitive nature" (as Jackson put it in a later letter), led to a crisis. MacDonald suffered a stroke in November 1917 during a move from Thornhill to a house nearer Toronto. He was confined to bed for many weeks and could do no work, although at the urging of Barker Fairley he did begin to write poetry seriously. He also began a series of short essays, published in the *Rebel*, between 1917 and 1920.

By the late spring of 1918, MacDonald was beginning to recover and was well enough in May to give a lecture to the Graphic Arts Club. He accomplished relatively little work before the autumn, but then he received an invitation from Harris to go on a sketching trip north of Sault Ste Marie, along with Franz Johnston and Dr MacCallum. Here is how Harris described the proposed trip in his letter of invitation:

The trip – overnight on C.P.R. to the Soo. Next day at the Soo we enter a caboose which will be our home while in the North. Said caboose is hitched on to some train or other hauled to a siding in the Agawa Canyon 120 miles north of the Soo [and] left there for two or three days while we proceed to get a strangle hold on the surroundings. From mile 120 we are picked up by a down-going train and left on another siding for a few days and again picked up and left on still another siding and so on until we land in the Soo with a mass of sketches and C.P.R. ourselves home again.

Because of his recent illness, MacDonald protested faintly that he might slow the others down, but Harris brushed aside his concerns, warning him only that Dr MacCallum "snores on occasion."

This first of two boxcar sketching trips to the old-growth wilderness above Lake Superior took place in September 1918. The country made a huge impression on MacDonald: he described it as "ruggedly strong, large, homely, free, and frankly simple in colour," and made references to Dante and Shelley in his attempt to characterize its prelapsarian qualities. In his article about the second trip, made in September 1919, he continued the Edenic metaphor by calling the Algoma Central Railway the Arcadian Central Railway. If the Algoma landscape struck him as arcadian, it was a distinctly Canadian version of paradise: waterfalls, rivers, huge trees and rocks, all limned in the brilliant colours of autumn. He thought it the very spirit of the new world, far from "the overblown beauty of the recognized Art countries." Although on both trips MacDonald and the others travelled in the relative ease of a railway car outfitted to keep them warm and comfortable, he felt, and expressed, a kinship with the explorers.

In a 1929 lecture comparing poetry and painting, MacDonald described the Canadian painters as "bolder, clearer, more original, larger, sunnier, more barbaric & natural, more *Canadian*." (By contrast, he thought the poets "in the anthological mass" rather "tame & small.") That series of adjectives, culminating in the italicized *Canadian* used as a kind of shorthand, could well serve to characterize the painting that came out of the two Algoma expeditions. MacDonald was awed and thrilled, as Jackson put it, and the multitude of sketches he made (typically on 8 1/2" and 10 1/2" boards) resulted in a remarkable series of fine paintings executed between 1918 and 1922, among which are some of the sacred relics of Canadian landscape art.

The visits to Algoma were the final element in the alchemical experiment that led to the formation of the Group of Seven. A transitional Algoma painting like *The Wild River* of 1919 provides a peep-show view of MacDonald flexing his technical

muscles still within a very design-oriented approach to composition. He had not quite managed to translate the marvellously free and partially abstract style of his oil sketches to the more formal context of a large-scale canvas. *The Little Falls* of the same year or *Algoma Waterfall* of the following year, however, show him in ecstatic control of his new material. The freshness of these and other works – *Falls*, *Montreal River*, and *Leaves in the Brook*, or *The Solemn Land* and *October Shower Gleam*, which are more stately – arises from the way MacDonald put his technical mastery at the service of exploring hitherto unpainted territory. "More barbaric & natural" these canvases certainly were; they have little relationship to any other Canadian painting up to that time.

In the last months of the war, when the first Algoma trip was undertaken, four members of the soon to be formed Group were still involved with war-related work. Varley and Jackson were in France, and Lismer and Johnston had done some war pictures of the home front. (Harris had enlisted in 1915, but was discharged for medical reasons two years later.) The end of the war meant that all seven painters came together again in Toronto for the first time since 1915. The flowering of all the arts, which had been taking place for a decade or so, increased in the first years after the Armistice. Canadian military successes supported a growing nationalistic confidence, which found expression both politically and artistically. Not surprising, then, that the same spirit of the times saw the founding of the Canadian Authors Association (1921) or evoked F.O. Call's able defence of free verse in the foreword to his 1920 book *Acanthus and Wild Grape:* "The modern poet has joined the great army of seekers after freedom, that is, he refuses to observe the old conventions in regard to his subjects and his method of treating them." Nor that the seven painters should form "a friendly alliance for defence," as MacDonald put it.

The coming together of these artists merely formalized informally, as it were, an association of several years' standing. The seven shared certain technical interests and a common subject matter, although differences were marked from the start. Varley, for example, concentrated on portrait painting and was less devoted to landscape

then than the others. The credo (to use William Colgate's term), as published in their first group exhibition catalogue, could find a commonality only in the shared view that "an Art must grow and flower in the land before the country will be a real home for the people," a banal enough generalization and in a certain sense not even true. Franz Johnston exhibited with the Group only once, and over the eleven years of its existence it would include A.J. Casson, Edwin Holgate, and L.L. Fitzgerald in addition to the original members, making it often a group of fewer than or more than seven.

MacDonald, whom Casson remembered as "the springboard for the group," was the eldest, and, with Harris, the Group's main motivating force. These two painters and Johnston had exhibited some of their Algoma work in Toronto in 1919. That same year saw the publication of MacDonald's essay "The Canadian Spirit in Art," a piece in which he himself made a parallel between the "initiative, energy and stamina" demonstrated in Canada's war effort and the "self-determination which will enable our people to make their necessary and fitting Art contribution to the common treasure of the world." It is clear from this article that MacDonald had arrived at a point of great self-confidence by 1919-20. The magisterial qualities of a canvas like *Autumn in Algoma* or the playful mastery of *Mist Fantasy* (in which his old interest in art-nouveau rhythms is displayed again) show how deeply in control he was – "soul-steadied," as Lawren Harris put it privately. It was Harris who financed the Algoma trips.

The first Group of Seven exhibition took place in May of 1920 at the Art Museum of Toronto and, at the Group's invitation, included three Montreal painters. MacDonald showed three works – *The Beaver Dam*, *The Little Falls*, and *The Wild River*, all of them early fruits of the Algoma trips. The catalogue openly invited "adverse criticism" but the press response was mainly good. "Seven Painters Show Some Excellent Work," ran a headline in the *Daily Star*. One might usefully compare the Group's debut exhibition, and the encouraging notices it elicited, with a parallel literary debut, the publication in 1936 of the anthology *New Provinces*, where the

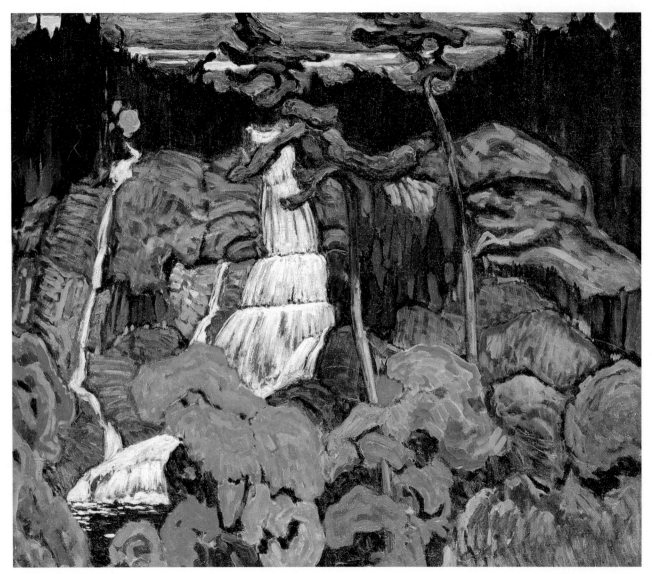

Algoma Waterfall

40

poets F.R. Scott, A.J.M. Smith, A.M. Klein, and Robert Finch first appeared in book form (the other two poets included, Leo Kennedy and E.J. Pratt, having already published full-length collections). This particular group of six met almost uniform hostility and risible sales. They had also had to pay for the book themselves, despite the fact that it bore the Macmillan of Canada imprint. These poets were on average a generation younger than the members of the Group of Seven (Pratt was born in 1882, the same year as Jackson, but was a good deal older than the other five), yet their version of modernism, launched a decade and a half after the first Group show, received nothing of the comparative warmth accorded the painters. Augustus Bridle reviewed *New Provinces* for the *Daily Star* in a column that also reviewed a Group of Seven retrospective. The exhibition he called a "glorious apocalypse," but the book got a much more reserved and mixed reception.

MacDonald went to Algoma for the last time in the fall of 1920, when he and the others stayed at a cottage rather than using ACR 10557, the boxcar that had been put at their disposal previously. Good notices or not, MacDonald's canvases were on the whole not finding buyers, and money must have been a continuing problem. He continued to freelance, and among other commissions found some work at the newly opened Hart House Theatre in the University of Toronto. Roy Mitchell, its first director, not only had him illustrate his book on Shakespeare for amateurs, as already mentioned, but brought MacDonald into the theatre to co-design, with Harris, a production of the *Chester Cycle* of mystery plays. Augustus Bridle called the stained-glass window that MacDonald did for the stage "a masterpiece of devotional beauty." But his decade of self-directed freedom was coming to an end. The second Group of Seven exhibition took place in May of 1921. As there were no invited contributors and Johnston chose not to show, the half dozen remaining painters hung more canvases than the year before – six in MacDonald's case, ranging from the intimate but lively *Batchawana Rapid* (1920) to the panoramic *Forest Wilderness* (1921). *The Solemn Land* had been sold to the National Gallery of Canada that spring from the Ontario Society of Artists show, which must have encouraged him a good deal. But it can be assumed that by then he

J.E.H. MacDonald and Franz Johnston, Algoma, 1919

had already said yes to the Ontario College of Art's offer to join the faculty as an instructor in decorative design. His old teacher George Reid was principal, and Lismer had been hired as vice-principal in 1919.

Many of MacDonald's most accomplished and best-known paintings were done in the last years of his decade of freedom from regular work. He was indisputably at the height of his powers, and found in the Algoma country the perfect visual cosmos on which to exercise them. The canvases range from the lyrical to the epic, but they are resiliently non-anecdotal and thus easily canonized as the epitome of Canadian landscape art. All the same, they have survived more than half a century of parti-pris philosophizing and remain fresh and vital works – "the beauty / of strength / broken by strength / and still strong," to quote from A.J.M. Smith's "The Lonely Land," a poem included in *New Provinces* and inspired in part by *The Solemn Land*.

J E.H. MACDONALD read and wrote a great deal, and in this and the following chapter we will break from the narrative of his life to examine first his activities in the book arts, the graphic arts, and related work, and secondly his accomplishments as a poet, essayist, and lecturer-polemicist.

Both as a full-time commercial artist and as a freelancer from 1911-21, MacDonald carried out commissions of all kinds. On a reduced scale he continued to do so even after he began teaching at the Ontario College of Art. Of his earliest work very little is known. Paul Duval cites a letter from 1897 in which MacDonald describes with understated humour the process of designing a label for Dr Clarke's Stomach and Liver Tonic. More than twenty years later, his advertisement for Ely Ltd., which appeared in an 1919 issue of the *Lamps*, the magazine of the Arts and Letters Club, is undoubtedly typical of his design work overall. (The content of this particular ad is a little odd, perhaps; not only is there no address or telephone number indicated, it is not even stated what the company does. It was a Toronto men's clothing store.) The calligraphy is accomplished, and the decoration is characteristic of MacDonald's graphic output, which included illuminated manuscripts and the title-pages of some of the books he designed for McClelland & Stewart.

In one of his OCA lectures, MacDonald defined the verb *design* as "to stamp with the mind." He called this definition "picturesque," but it is clear that he understood design as a serious artistic activity involving much more than the mere decoration of a text or the creation of a more or less invisible vehicle to carry a message. Later in the same lecture he emphasized the importance of "working for a local development of classical ideals," a statement that demonstrates a philosophy of

The Book Arts and Other Design Work

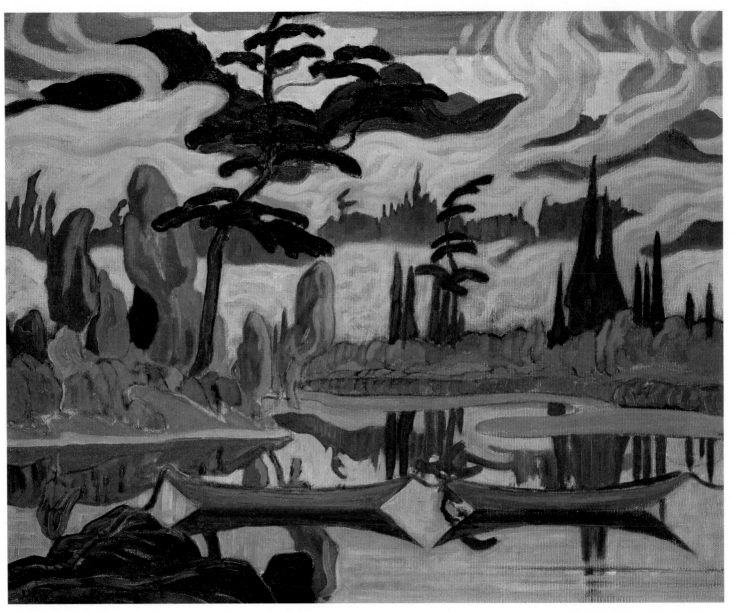

Mist Fantasy

design parallel to his views on painting. It was not enough merely to copy foreign models, important though they were. "Here or nowhere is our ideal."

MacDonald's own sources were primarily in the English designers of the late nineteenth century. He praised Walter Crane and William Morris and mentioned Lewis Day, and his work often incorporated the serpentine line and flat pictorial space characteristic of art nouveau. Some of his borders reflect the work of Morris in the Kelmscott Press books, of Laurence Housman, and of Reginald L. Knowles's designs for the Everyman Library series of reprints published by Dent. Of William Blake, whose work was rediscovered after the middle of the nineteenth century and much admired by the practitioners of art nouveau, MacDonald remarked that "in him the grand imaginative designer & book decorator rises again." The graphic arts ideals of European (as distinct from British) art nouveau certainly corresponded generally to MacDonald's own, although it is uncertain how well he actually knew such work. The unity of text and decoration argued by Maurice Denis or shown in the famous poster designs of Eugène Grasset surely formed part of the design ideals still in the air when MacDonald was in England.

Reference has already been made to MacDonald's admiration for several Toronto designers and artists active from the 1890s onward. He particularly respected A.H. Howard (1854-1916), whom he described as "an old master who lived among us as a young friend" and whose memorial exhibition at the Art Gallery of Toronto in the spring of 1916 he reviewed for the *Globe*. In that review he commented on Howard's use of local flora and fauna in his ornamental designs. Howard's cover for the 1904 Toronto Art Students' League calendar, for example, included thistles and maple leaves, as well as some varieties of flag (or milkweed?) and wild rose (a cinque-foil perhaps). MacDonald himself emulated this fidelity to "a local development of classical ideals" in his February decoration in the same calendar, in which he portrayed rabbits, oak leaves, and wildflowers, including sweet everlasting. (The letters and numbers on this early example of his graphic work are very reminiscent of art-nouveau typography and calligraphy.) MacDonald undoubtedly also drew some

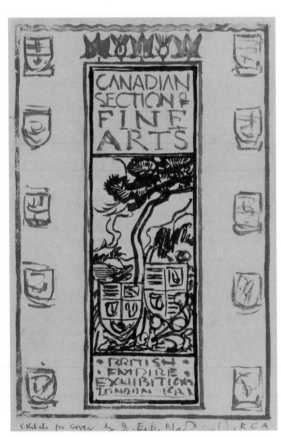
Catalogue Cover Sketch for British Empire Exhibition

inspiration in this regard from the work of Robert Holmes, the wildflower painter. Holmes was president of the Toronto Art Students' League during most of its existence, and taught at the Ontario College of Art from 1912 to 1930. He died addressing a college graduation dinner at the Arts and Letters Club, and MacDonald memorialized him the following year in the *Tangent*, the OCA student magazine. "That future he spoke of," wrote MacDonald at the end of his article, "will soon bring the trillium and hepatica and lady-slipper to our woods again. Most of us who knew Robert Holmes will see a deeper beauty in them now, and may possibly try to put some of that into our work and our living." All of these flowers, especially the trillium, show up often in MacDonald's design work.

A number of MacDonald's commissions involved magazine and catalogue covers. These and other related assignments, such as an undated postcard, often combined heraldic elements with trees and flowers. The catalogue covers for the fiftieth exhibition of the Ontario Society of Artists (1922) and the 1925 British Empire Exhibition at Wembley (for which the original sketch survives) are typical. The first is dominated by trilliums, the official flower of Ontario, both in the rectangular border and as part of the central design within the doubled circle bearing the society's name. Two escutcheons, one with maple leaves and the other with a palette, hang from the branches of a maple. In the Wembley catalogue, the arms of the then nine provinces and one territory are drawn on either side of a double-ruled rectangular frame, surmounted by maple leaves and pine-cones, within which are a drawing and the titling. The drawing includes two coats of arms as well as wildflowers (iris and trilliums, among others), with a northern scene in the background and a recognizably Group of Seven pine dominating the middle. MacDonald was a highly skilled letterer, and here, as in his book designs, he preferred to letter the title rather than to work with type.

Every member of the Group of Seven was involved at one time or other in book design or decoration, some more than others. Lawren Harris did perhaps the least. He illustrated Norman Duncan's *Going Down from Jerusalem* (1909) and designed his own

collection of poems, *Contrasts* (1922). J.E.H. MacDonald worked in this form the most, even if one counts only the commissions he carried out for commercial publishers. He undertook more than a dozen books during the 1920s, mostly at the invitation of John McClelland, one of the two founders of the Toronto publishing house that started out in 1906 as McClelland and Goodchild, then became McClelland, Goodchild and Stewart for a while, and McClelland & Stewart in 1918. He also designed one book for the Musson Book Co. in 1925, as well as the series cover and headpiece for the famous Ryerson Poetry Chapbooks. A later version of the chapbook cover was modified by Thoreau MacDonald in 1942 and was signed with the initials of both artists, while the headpiece was replaced by a title Thoreau had lettered.

In the absence of the relevant archival records, which were burned, it is impossible to specify exactly what MacDonald's instructions from McClelland and Stewart were. It is unlikely that he designed these books in the fullest sense of the word, that is, choosing type and binding cloth in addition to laying out the page, and so on. What he did do was to draw the title pages, endpapers, and dust jackets, and to decorate and letter the bindings, using labels in one or two cases. A few of the books also have decorated or historiated initial letters, for example, Archibald MacMechan's *The Book of Ultima Thule* (1927). As a whole, his style of book decoration is quite different from his manner of painting. The dust-jacket and endpapers of Laura Salverson's novel *Lord of the Silver Dragon*, for example, which incorporate the sailing-ship motif he often used (his logo for the Arts and Letters Club employs a similar Viking-style boat) have an almost comic-book air about them. MacDonald may indeed have been poking a little fun at Salverson's weighty and serious historical fiction. Birds are a common motif on the endpapers of several of these books, and the eagle at the centre of his design for both the endpapers and the title-page of Pauline Johnson's *Legends of Vancouver* (1922) reappears in architectural decorations he executed in 1928.

Like all good book designers, MacDonald incorporated motifs and elements drawn from the texts themselves. The fleurs-de-lis on the upper board of Marjorie

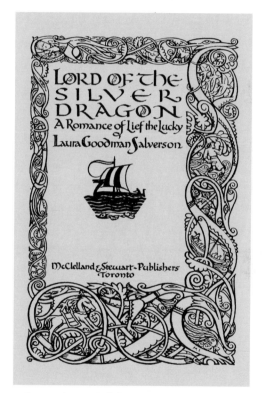

Title Page for *Lord of the Silver Dragon*

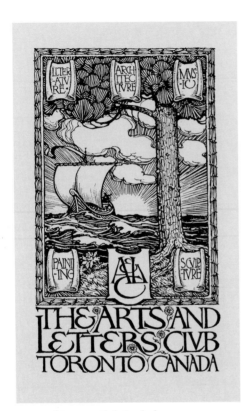

Arts and Letters Club Bookplate

Pickthall's *The Woodcarver's Wife* (1922) reflect the Quebec setting of the play that makes up half of the volume. The binding and title page of Isabel Ecclestone Mackay's *Fires of Driftwood* (1922) directly illustrate the title poem, and the figure of Pan is present in both the title page and the endpapers of A.M. Stephen's *The Rosary of Pan*. The title page of Francis Beatrice Taylor's *White Winds of Dawn* (1924) is, atypically, typographic only, but the endpapers depict a stylized sun rising over the sea, with MacDonald's favoured sailing-ships flanking it. The title pages of two other books, Grace McLeod Rogers's *Stories of the Land of Evangeline* (1923) and Archibald MacMechan's *Old Province Tales* (1924), are lettered rather than set in type, and the decorations of the former include several typical MacDonald elements: a heraldic shield, ships, flowers, and pine-cones, as well as the figure of Evangeline herself. This book is also illustrated with twenty-eight small drawings, for which MacDonald certainly recalled his trip to Nova Scotia in the summer of 1922. It and Roy Mitchell's *Shakespeare for Community Players*, mentioned in the previous chapter, are the only two books actually illustrated by MacDonald. He once spoke highly of Edwin Holgate's illustrative work in Georges Bouchard's *Other Days Other Ways*, which Louis Carrier commissioned and published in 1928, but none of his own book work was as elaborate as Holgate's for this collection of Québécois sketches.

MacDonald's graphic labour extended to manuscript illumination, posters, and occasional magazine illustrations, such as the amusing "Paul Bunyan Takes an Evening Stroll in Algoma," which Joan Murray has called "the only true illustration in the entire history of the [*Canadian*] *Forum*." The illuminated manuscripts which MacDonald made were all done on commission, usually to memorialize someone or to mark an important occasion. An example, such as that made for Charles Lewis of the Eaton Drug Co. in the mid-1920s, shows exquisite workmanship; the calligraphy is almost typographic in its proportion and balance, the colours are brilliant. Some of the illuminations still reflect, even in 1925, MacDonald's roots in art nouveau. The style may be somewhat passé for the period, partly because clients who were likely to want this sort of work would have had fairly conservative taste. Many anonymous Canadian calligraphers

Endpapers for *Legends of Vancouver*

Illuminated Leaf for Eaton Manuscript

undertook such commissions from the nineteenth century on, often for diplomas and other souvenirs of lofty occasions. But none made such beautiful pieces as MacDonald, however strong his reservations about the seriousness of such work.

His bookplates were of equally high quality and probably more congenial to him. Thoreau MacDonald claimed that his father designed about twenty bookplates, a few for institutions such as Hart House but most for individuals. Before MacDonald's time, the vast majority of Canadian bookplates were of two sorts: simple typographic labels, such as those printed in the shop of Browne and Gilmore in Quebec City as early as the 1790s, and armorial plates (or die-sinkers as they were called, after the process used to engrave them). These early bookplates mimicked the styles fashionable in England and France, and were indeed often produced there. As a group William Colgate called them "dull, uninteresting, and artistically pedestrian." It was not until MacDonald and a few of his contemporaries turned their hands to bookplate design that this form of graphic art achieved some individuality in Canada.

An unprinted bookplate design for his wife from 1900 features a drawing of a house and trees and is quite airy and uncluttered, particularly compared to the book design of the same year, said to be his first. His first *printed* bookplate, that of 1911 for the Arts and Letters Club, is more typical; it arranges in its small compass several of MacDonald's favourite motifs, such as a Viking ship and a pine tree. Bookplates executed for the library of Dalhousie College and for William Lawson Grant combine illustrative elements with more conventional armorial designs. Those for friends such as Dr MacCallum, J.W. Beatty, and Basil George Morgan (an amateur actor) are more original; they are almost pure illustration and clearly relate to MacDonald's book decoration work. The bookplate itself is a very conservative format, but MacDonald's contributions helped to revitalize a tired art. Thoreau MacDonald was a noted bookplate designer as well.

It seems likely that J.E.H. MacDonald must have designed a number of posters, and probably had a hand in producing many others as a young lithographer and commercial artist. Only a few have survived. Posters by their nature are ephemeral,

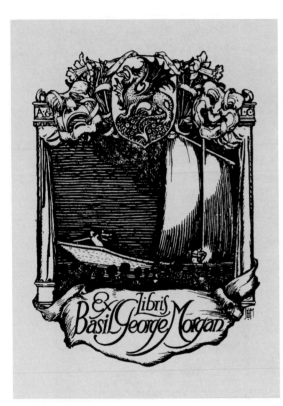

Basil George Morgan Bookplate

although there were many early poster collectors in Canada, as many as a thousand in the mid-1890s, by one report. Of the few MacDonald posters extant, one for Canadian Northern Steamships is strikingly reminiscent of *The Supply Boat*, the largest of the MacCallum-Jackman mural paintings, though Robert Stacey tentatively assigns it to 1909 in his history of the Canadian poster. "Canada and the Call," which MacDonald executed pseudonymously for a Royal Canadian Academy competition in 1914, is a colour lithographed poster announcing an art exhibition in aid of the war effort. Like a Canadian National Exhibition poster from 1919, it has a more strongly illusionistic pictorial space than was common in the work of the most famous of the European poster designers, Toulouse-Lautrec or Eugène Grasset, for example. The two figures in the foreground of the 1914 poster, representing a Canadian farmer and the British Empire, portray the easy sentimentality that was commonplace in the early months of the war, feelings which quickly disappeared as the struggle dragged on. The equally superficial embodiment of Victory in the 1919 poster (a slightly older Empire maid astride a frisky horse) was certainly the order of the day, but surely does not adequately express MacDonald's own deeper feelings about "the throbbing spell of War," as he put it in a poem entitled "Spring Evening – Wartime."

Part of the coming of age of the arts in Canada during the 1920s was a renaissance in drama and the theatre. From its beginnings in 1908, the Arts and Letters Club sponsored regular plays and revues, and these activities led to the founding of Hart House Theatre in 1919 at the University of Toronto. Its first director, Roy Mitchell, started out as the master of theatrics at the Arts and Letters Club. He was a pioneer of modernist theatre, and his book *Creative Theatre* (1929) anticipated many much later radical developments in the North American stage. At the Arts and Letters Club, Mitchell undertook to present plays by W.B. Yeats, Maurice Maeterlinck, Rabindranath Tagore, and others, which could not have been produced professionally in Canada at that time because of their experimental nature.

Through the club, Mitchell met the Group of Seven, several of whom contributed designs for Mitchell's plays both there and, later, at Hart House. MacDonald's

Northern Steamship Line Poster, c. 1909

The Supply Boat

designs for the theatre are perhaps the least known part of his work, and although not substantial, they formed an integral portion of his multifarious creative life. His contribution to Mitchell's 1911 production of Yeats's *Shadowy Waters* survives in the form of a published drawing in the *Lamps*. Better documented is Mitchell's Hart House production of the *Chester Cycle* of mystery plays which he had earlier staged in New York at the Greenwich Village Theatre. The set, in Mitchell's words, was designed "to suggest a church chancel. At the back is a tall stained-glass window and in the front of it an altar with candelabra and a bowl of lilies." For the Toronto production, the much-admired stained-glass window designed by MacDonald was eight feet in diameter.

Mitchell was a devoted theosophist and reader of Whitman (his annotated copy of *Leaves of Grass* has survived), and his approach to the theatre was fired by his search for revelation. His two years as director of Hart House Theatre and two further years, somewhat later, spent teaching scenic design at the Ontario College of Art, had a liberating effect on the Toronto stage, and helped to make possible the work of Herman Voaden, MacDonald's other important dramatic associate. Voaden was both a director and playwright, and much of his work was directly inspired by the ideas and images of the Group of Seven, especially their reverence for the North. In 1939, he described in a speech the feelings evoked for him by *The Solemn Land*: "austere and lonely music richly coloured – the vastness of a cathedral design – I see this state in terms of dance – against such a background – I can hear a chanting of voices – singing – or verse speaking." Voaden called his version of the Wagnerian *Gesamtkunstwerk* "symphonic expressionism."

MacDonald did not actually design a production for Voaden, although Lowrie Warrener, one of the Group's protégés, worked closely with him on several plays staged at the Central High School of Commerce, where Voaden was head of the English department. (Through Voaden's influence the school acquired several Group of Seven paintings.) In 1929-30, however, MacDonald agreed to be a member of a jury with Merrill Dennison, the playwright, and J.D. Robins, a professor at the University of Toronto, to judge a playwriting contest sponsored by Voaden's school. The rules

Sketches from *Shakespeare for Community Players*

required that the plays submitted have a setting in the North, based more or less directly on a Canadian painting – J.E. Middleton's *Lake Doré* on Franz Johnston's *The Deserted Cabin* and Dora Smith Conover's *Winds of Life* on Thomson's *West Wind*, for example. In all, forty-nine plays were entered and six were eventually published by Copp Clark in 1930. *Six Canadian Plays* attests to the already pervasive influence of the Group on Canadian culture. The illustrations include pictures by Harris, Lismer, Thomson, and MacDonald.

In his autobiography, A.Y. Jackson wrote of MacDonald "that he was a designer before he was a painter [as] is evident in almost everything he painted." MacDonald practised as a designer in many forms long after the economic necessity to do so had disappeared – demonstration enough that design was in his blood. Even apparently improvisational canvases like *The Tangled Garden* or *Leaves in the Brook* betray a covert formal planning that clearly arises from MacDonald's innate design sense. When he remarked in 1929 in a lecture that "a picture is a perfected enclosure of space seen with heightened vision," it was the word *perfected* that reflected his training as a designer. It was the root of his style, and renders even his most ephemeral work immediately recognizable and of lasting interest.

The poets are girl guides on Parnassus, & the painters are boy Scouts in Beulahland.
J.E.H. MᴀᴄDONALD

I will candidly admit that most artists worth their salt, deserve, get, & pass along, a good deal of preaching as they go.
J.E.H. MᴀᴄDONALD

The Writer

O N THE SECOND DAY of September 1932, about ten weeks before MacDonald's death, William Arthur Deacon, then the literary editor of the Toronto *Mail and Empire*, responded to a letter from a rural Ontario high-school principal who had written to him about the Canadian poets his junior matriculation class was studying that year. Among the poets whose inclusion on the curriculum surprised Deacon was J.E.H. MacDonald. "I know [him] personally," wrote Deacon. "He is the most successful painter of the Group of Seven. He is no poet, but has written a few trifling lyrics, very slight, and these, or some of them, got published in The Canadian Forum because it was then in the hands of a small U. of T. coterie very friendly to MacDonald as a painter and personally."

Deacon was the first to admit that he was not a good judge of poetry, however fine his other literary instincts, and so we do not have to take his rather harsh verdict on MacDonald's poetry as the final word. MacDonald was not a poet of major importance, but like many painters – Lawren Harris, Bertram Brooker, Eldon Grier, and Roland Giguère among Canadians come to mind – he liked to write poems and was not without talent. (The opposite phenomenon, of poets who also paint, is equally common in Canada. One thinks of bill bissett, P.K. Page, and Madeleine Gagnon as interesting examples.)

MacDonald had a lifelong interest in literature and was a close reader of Robert Burns, the American transcendentalists (Whitman, Emerson, and especially Thoreau), and other writers, including Ruskin, Carlyle, and Tolstoy. His son, who was named after Henry David Thoreau, has testified to his father's affection for the naturalist writers W.H. Hudson and John Muir and to his lack of interest in the novel:

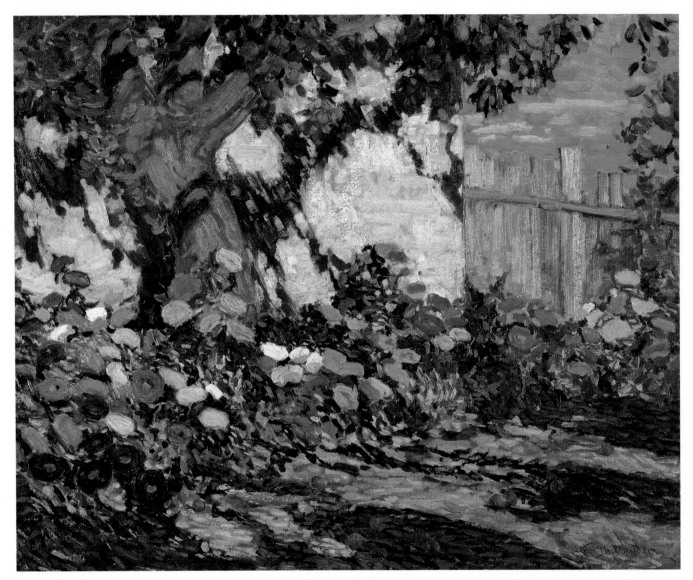

Asters and Apples

"I never saw him read any fiction except Turgenev's *Two Friends* and *Father and Sons*, which he greatly admired." He was certainly familiar with Canadian poetry, which he may well have read in John W. Garvin's anthology *Canadian Poets*, the second edition of which was published by McClelland & Stewart in 1926 when he was still doing commission work for the house. In his 1929 lecture on poetry and painting he remarked on how most early Canadian verse "seems to have been written in dark studies or parlours, on Sunday afternoons, with portraits of Queen Victoria or the Fathers of Confederation on the walls, and antimacassars for the poet to lean his noble locks upon, while his gaze rested on the family Bible under the bell glass of wax flowers or humming birds on the window table." MacDonald has amusingly put his finger on what the critic John Sutherland, in his famous introduction to the anthology *Other Canadians* (1947), later called "the literary smell of our poetry – our sensation of being on the inside of a jar of preserves."

The fustiness and elevated twaddle of Victorian Canadian poetry persisted well into the twentieth century. Not until the 1920s did there appear a group of young poets, disparate and not necessarily all familiar with one another's work, who were determined to revolutionize both the form and the subject matter of poetry in Canada. Formally they were suspicious of rhetoric and metrical regularity, and for the subjects of their poems they chose the immediate world of their senses in all its particularity over the generalized emotion and spiritualized perceptions of the older poets. A poem from 1926 by F.R. Scott entitled "New Paths" might almost have served as a manifesto for the new poetry, although it went unpublished at the time. "Here is a new soil and a sharp sun," it said in a line that might well have been describing a Group of Seven painting. Scott had in fact first seen the Group's work in the same year during which "New Paths" was written. The poem concluded:

> Turn from the past,
> Walk with me among these indigent firs,
> Climb these rough crags

And let winds that have swept lone cityless plains,
Gathering no sad tales of past endeavour,
Tell you of fresh beauty and full growth.

The relationship between these lines and the spiritual address of the Group rooted in the northern landscape is easily recognized. Scott's friend A.J.M. Smith wrote a poem at about the same time called "Group of Seven," which he published in the *McGill Fortnightly Review*. It was later revised and became "The Lonely Land," the poem quoted at the end of chapter three.

Poets of a rural upbringing, whose sense of the local arose directly from their contact with a non-urban landscape, were important contributors to the vortex of new ideas and formal imaginings that was the Canadian poetry of the 1920s. F.O. Call, whose *Acanthus and Wild Grape* has been mentioned as including an important preface regarding the use of free verse, was actually most effective as a poet who celebrated the Quebec countryside. *Blue Homespun*, published by The Ryerson Press in 1924 with pen and ink drawings by Orson S. Wheeler, looks and feels a lot like MacDonald's own posthumous collection, *West by East and Other Poems*, though Call's book is a sonnet sequence and MacDonald did not evince much interest in such formal circumstances (his sonnet "Winter Evening" is an exception). The work of Raymond Knister, who was from southwestern Ontario, dealt realistically with farm life in a poetic style modelled largely on classic modernists like Ezra Pound and William Carlos Williams, with whom Knister shared space in little magazines such as *Poetry* and *This Quarter*. Knister died accidentally in 1932 at the age of thirty-three, and his poems were not collected for publication until 1949, when Dorothy Livesay, another 1920s modernist, edited them for The Ryerson Press. They have a spirit quite similar to MacDonald's Thornhill pastorals, though their formal range is greater.

At the urging of Barker Fairley, MacDonald began to write seriously after his stroke in 1917 as "a form of occupational therapy," in Thoreau MacDonald's phrase. His poems appeared in the *Rebel*, the *Lamps*, and a few other magazines, but especially,

Caricature of J.E.H. MacDonald
by Franz Johnston

as William Arthur Deacon noted, in the *Canadian Forum*, first in the early 1920s and then a later group in the 1926-29 period. He intended to collect them into a book and illustrate it himself, but he died before he could do so. In the end, it was his son Thoreau who chose the poems for *West by East* and illustrated them. Writing to Lorne Pierce at The Ryerson Press in 1937 about the possibility of a French translation of the poems, Thoreau expressed his conviction that his father's poems "will some time be a landmark in the expanse of Canadian literature." He had published five of the poems from the book in 1933 as *Village & Fields: A Few Country Poems* under his own private imprint, the Woodchuck Press. The following year he also printed a pamphlet called *My High Horse*, a humorous poem in mock heroic couplets.

The poems themselves are mostly low-key and small-scale and concentrate on things "out the window," as one might suspect, given their origin during MacDonald's convalescence. The backyard, the garden, and the weather predominate, although the war, too, is a palpable presence. All of these motifs come together in a representative poem like "Spring Evening – Wartime":

Cover Design for *My High Horse*
by Thoreau MacDonald

The pines rank solemnly about
The hills that edge the level lands,
Where stripes of purple ploughing lie
Between broad grey-green bands.

The troubled sky is hung with grey
In thickened roll and drooping fold,
A building robin bustles near
With pleasure widely told.

The old man lays the burnished plough
On the green headland till the dawn, –
He tells of wounded sons abroad, –
His horses dream withdrawn.

In livid spaces of the sky
A lonely airplane circles far,
Weaving through cloud and field and heart,
The throbbing spell of War.

Although MacDonald's verse does not have the individuality or range of E.J. Pratt's *Newfoundland Verse* (1923) or the modernist feel of Bertram Brooker's poetry, it is accomplished in its way and, for its time, unusually spare. It is mostly forgotten now, although a religious poem entitled "Gallows and Cross" survived as late as 1942 in the first edition of Ralph Gustafson's *Anthology of Canadian Poetry* (only to be dropped from the later editions) and was reprinted with "The Manger" in a recent collection entitled *Christian Poetry in Canada*. "Painting holds the mirror up to nature," MacDonald once wrote privately with some asperity, "but poetry has a tendency to be looking at herself in her little vanity glass." His own poems went against that inclination to self-absorption which he regretted in much of the work of his contemporaries.

As a teacher, MacDonald told his students to read poetry. "Art Students should like poetry," he said. "It is an art expression & links with all." He also recommended that art students should try to write poetry as part of their training: "An art student should have an eye for the picturesque in literature as well as in nature." Thoreau MacDonald thought that his father stopped writing poetry after his recovery in 1918, but it is clear from the many unfinished and uncollected poems among his papers that he continued to write it until the end of his life. If he was, as Thoreau wrote in a note, "a spare time painter," he was even more obviously a spare time poet. He wrote poems much as he sketched – between times, to exercise his faculties.

MacDonald also wrote a good deal of prose. Most of his articles meant for publication date from the years 1916-20, although his first published piece – the famous reply to Gadsby's "Hot Mush School" review – was published in 1913, and later he also wrote an article for the *Canadian Forum* in 1923, a descriptive piece about the West that appeared in the *Canadian Bookman* in 1924, a piece about architecture in the Toronto *Telegram* in 1929, and the obituary for Robert Holmes in 1930, cited in the previous

Cover Design for *Village & Fields*
by Thoreau MacDonald

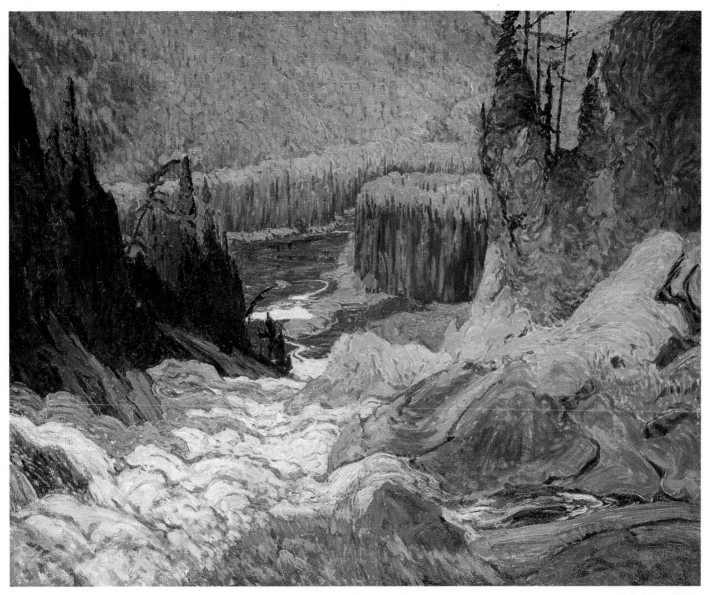

Falls, Montreal River

chapter. In the 1920s, most of his writing took the form of lectures, some meant for public occasions, others for students in the decorative design department at the Ontario College of Art, though occasionally a public talk, such as one he gave to the Toronto Typothetae in 1930, would be a version of one of his OCA lectures. His prose style, like his lecture style, was, at least as far as the manuscripts permit one to judge, personal, lively, laced with humour, and always intelligent and well-informed.

The main body of MacDonald's published prose is a series of eight articles that appeared in the *Rebel*, ranging in tone from the serious – a piece on Tom Thomson and the installation of the cairn at Canoe Lake – to the somewhat frivolous – a compilation of student bloopers in art history called "A Hash of Art." From these one can glean a great deal about MacDonald's views on a number of subjects. They are not so polemical as his extended letters to the Toronto newspapers of 1913 and 1916, nor on the whole are they as visionary or defensive.

The Thomson piece, "Landmark of Canadian Art" (November 1917), did not "discuss the life and work of Tom Thomson, or Canadian art in detail," but memorialized MacDonald's old Grip associate and friend by describing the erection of the cairn, the text of which MacDonald had written and lettered and which is reproduced at the end of the article. The light-hearted cento "A Hash of Art" appeared in December 1917, to be followed the next month by "Art Crushed to Earth," the text of a talk given at the 1917 Ontario Society of Artists exhibition, where MacDonald showed *Harvest Evening* and *Asters and Apples* among other canvases. The show was the occasion for some reflections on the nature of art and on the relationship of art to its audience of critics and viewers. He begins by citing Emerson's opinion that "Art is the enlarger of life," and on that basis goes on to propose:

It is the work of the Canadian artist to paint or play or write in such a way that life will be enlarged for himself and his fellow man. The painter will look around him, like the Creator in Genesis, and finding everything good, will strive to communicate that feeling through a portrayal of the essentials of sunlight, or snow, or tree or tragic cloud, or human face, according to his power and individuality.

He then discusses the critic's role in the progress of art, and emphasizes the importance of the audience. "The influence of art should spread constantly outwards. We want a nation of art lovers rather than a cult of artists." In framing his rebuttal to the critics, MacDonald was undoubtedly remembering drubbings that he had received in the past.

"Art and Our Friend in Flanders," published in the February 1918 issue of the *Rebel*, was a response to letters from A.Y. Jackson, who was then still in Europe as a war artist. Jackson had written about one of his *bêtes noirs*, the Canadian taste for Dutch art and how, as MacDonald put it, "Dutch art, as sold in Canada, had only poisoned the taste and appropriated the dollars of Canadian buyers, making it doubly difficult for the Canadian painter to get a footing in his own country." His complaint inspired MacDonald's next article, "A Whack at Dutch Art," which followed in March, dealing head-on with the old problem of the gap between the artist and the taste of his audience, with particular reference to Canadian picture-buyers and their retrograde affection for Dutch painting. "Lovers of Canadian art," MacDonald wrotes, "are at present much like the early Christians in their catacombs. They are developing the faith of the future in secret, and the ground will open with them some day." His words towards the end of this important piece take on added significance when one remembers that the first Group of Seven show was just two years in the future:

The Canadian artist and the lover of Canadian art have been humble long enough. To be so any longer is to degrade a desirable virtue. To reverence great masters and older schools of painting is quite another matter from coming to the salute every time a dealer exhibits a picture with a Dutch name on it. Only by fostering our own Canadian art shall we develop ourselves as a people. The artists have blazed a trail, opening up a new country. The trustees of our National Gallery have shown themselves keenly interested in the movement, but government encouragement alone is not desirable. It is desirable that the horse and the wagon should remain connected for right transportation.

Two slightly later articles complete the series. "The Terrier and the China Dog" (December 1918) deals once again with the antagonism between the artist and the

critic, whose opposing views MacDonald sees embodied respectively in Whistler ("Nature is rarely right") and Ruskin ("Nothing but Nature is right"). MacDonald's sympathies naturally reside with Whistler, whose work leads him to remark that "the life of Art is freedom, and its spirit works best in innocent daring." MacDonald's self-confidence, evident in most of these articles, is particularly striking in this one, published shortly after his first trip to Algoma. He concludes by observing the increasing acceptance accorded "the China Dogs of Art": "The broad, free rendering of nature and unconventional landscape or figure, with the living spirit appropriately translated in strong, honest brushwork, is surer of appreciation in our exhibitions." MacDonald's penultimate piece for the *Rebel*, "Mentioned in Despatches" (March 1919), a brief look at Varley and Jackson as war artists, is equally cocky about the brilliant future of Canadian landscape art. "A Happy New Year For Art," his final article, is a high-spirited if minor piece in which MacDonald once again takes on the place of Canadian art. Its tenor is suggested by this slap with a glove on the cheek of art criticism: "The critic is only the fly on the chariot wheel. He may leave his place sometimes during the run, and annoy the driver or quicken the horse, but he can never take the reins."

"The Canadian Spirit in Art" (from the *Statesman*) and "ACR 10557" (from the *Lamps*), both mentioned in chapter three, also date from 1919, and taken together with the *Rebel* articles demonstrate what a fertile period the early post-war years were for MacDonald. His increased productivity as a painter at this time, and eventually his acceptance of a full-time teaching post, left him little energy to write for publication after 1920. Beginning in 1921 it is his OCA lectures and other talks to which one must turn to follow his developing ideas on art.

MacDonald's college lectures mainly deal with the history of lettering, printing, and the graphic arts. They survive in various stages of completeness, and sometimes in variant texts, in the papers given by Thoreau MacDonald to the National Archives of Canada. Although as student lectures they are limited in their terms of reference, they are full of characteristic insights and would be well worth publishing. His lecture

"Examples in Early Books," for instance, the second in a series on lettering, contains this interesting reflection: "There certainly is a beauty of plainness as well as a beauty of ornament. You can take your choice & attempt both. You will find, everything considered, the beauty of plainness harder to achieve." Such remarks are useful evidence in tracing MacDonald's ideas as an artist, for it is evident that he spoke to his students not as an art historian, however knowledgeable about tradition he may have been, but as a practising painter and designer. Only an experienced and self-confident artist could have advised, "Scheme first, plan next, specify next but change all the time," as Thoreau MacDonald claims his father once told an audience at the Ontario Association of Architects in a talk which, except for Thoreau's notes, has otherwise been lost.

The texts of a few of MacDonald's public lectures have survived and are important sources of information. Most of these have already been mentioned or cited, the most significant being the Whitman lecture given in 1926 to the English Association and the lecture on Scandinavian art delivered at the Art Gallery of Toronto in 1931. Two talks given at the Arts and Letters Club – the first on poetry and painting, the second on "The Decorative Element in Art" – are cornucopias of pithy observations. And lastly, a lecture on the work of John Constable, though less well-known (the occasion of its presentation is uncertain), attests to Constable's influence on an early stage of MacDonald's work. Its closing words suggest that it was composed at about the same time as "The Canadian Spirit in Art," the 1919 article whose chiliastic tone seemed to be preparing its public for the advent a year later of the newly founded Group of Seven:

We have a large country with three thousand miles of landscape to do, and a great vital, varied nature [i.e. Constable] to stand behind us while we do it. We have to experiment with different forms of expression to do this, but we cannot go far wrong, if we begin with nature rather than with other pictures.

Painting is the essence of the significant appearance
of things, intensified by unity of arrangement.
J.E.H. MᴬCDONALD

The Last Decade

ARTHUR LISMER REMARKED to his biographer that hiring MacDonald to "teach lettering with fine artistic insight, quote Whitman, the Bible, and Eastern philosophy" was part of his attempt to modernize the curriculum of the Ontario College of Art and in general to liven things up. MacDonald would be associated with the institution from the autumn of 1921 until his death in November 1932, first as a teacher of commercial art, for several years as head of the department of graphic and commercial art, then as acting principal for a year, and finally as principal, beginning in the 1929-30 academic year. One of his earliest students was the painter Carl Schaefer, who described him as an excellent teacher and "a wonderful poetic soul, full of humour and patience." The beginning of MacDonald's first full-time teaching year at OCA in 1921 coincided with the opening of the college's new purpose-built quarters, constructed after George Reid's architectural design.

MacDonald's skill and popularity as a teacher are unquestionable, but it is equally certain that, like many creative people who have fallen into teaching in order to furnish their table with bread and wine, he viewed the classroom as a mixed blessing. Towards the end of his life he complained in a letter to the OCA Council of "teaching & its associated troubles," and there is no doubt that his job permitted him relatively little opportunity to paint. Busy as he was throughout the 1920s, however, he still found the time to take on several freelance commissions. As we have seen, he designed a number of books for McClelland & Stewart, a use of his talents of which it is surprising he did not make more in the preceding decade. He undertook some architectural and church decoration as well, and of course he continued to sketch and to paint, though much less than before.

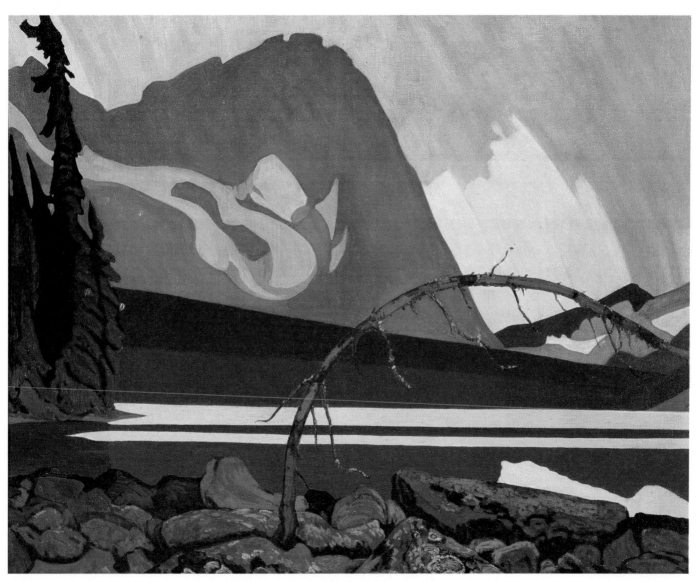

Rain in the Mountains

The third Group of Seven exhibition took place in May 1922, and once again MacDonald showed mostly canvases painted from his Algoma sketches. Among them, *October Shower Gleam*, acquired after MacDonald's death by Hart House, has an almost academic formal regularity (something of which he is rarely guilty) but is rescued by its magnificent colours and cinematic view. It is less subtle than *The Solemn Land*, but almost equally eloquent. *Algoma Waterfall* is a more understated yet romantic picture, and *Mist Fantasy*, although it reduces the wildness of Algoma to a stylized, even whimsical composition, is beautifully realized and gives a hint of the mountain paintings of MacDonald's last years.

MacDonald spent part of the summer of 1922, following his first bout of teaching, on his own, with his old friend Lewis Smith in Nova Scotia. The stay there was evidently a welcome break from Toronto after a heavy year of work. In a reflective letter to his wife, he admitted: "I *loathe* school and the thoughts of teaching." Sketching on the Atlantic shore took his mind off the responsibilities of home life. His Nova Scotia sketches and the handful of canvases made from them show a more sedate MacDonald, and it is suggestive of how he viewed them that none was included in any of the Group of Seven shows. The sea is an almost mute presence in a painting like *Church by the Sea* (1924), and the scene itself – in the sketch of 1922, the oil canvas, and the print published in 1925 as part of a portfolio of Canadian drawings – feels curiously unlocalized. MacDonald undoubtedly loved the sea, but his paintings of it at this time are overdomesticated. The Barbados sketches made in the last few months of his life have more power and liveliness, but these were never worked up into full-scale oil paintings.

In the following year MacDonald accepted what was the most interesting commission of his career, when he took on responsibility for the decoration of St Anne's Anglican Church in Toronto. Using Byzantine models, several artists chosen by MacDonald, including Group of Seven members Frank Carmichael and Frederick H. Varley, as well as MacDonald himself and his son Thoreau, did the actual painting. Although church decoration was not uncommon in Quebec (even Borduas would do

some ecclesiastical painting early in his career) it was all but unheard of in Protestant Canada. MacDonald was quick to point this out in an article he wrote later for the *Journal of the Royal Architectural Institute of Canada*: "Canada seemingly gets her walls painted, but not decorated. Giotto would be out of a job among us, and Michel Angelo would move from Toronto to New York." But St Anne's, built in 1908, was paid for by 1923, and its rector, Canon Lawrence Skey, "wanted another [debt] to carry, as exercise for his people," as MacDonald put it in a *Canadian Forum* article on the project. A bequest as well as parishioner support permitted the work to be carried out.

MacDonald contributed three paintings to the St Anne's series, and their style beautifully combines classical Byzantine qualities with features characteristic of the artist's illustrative work. The vignette of a female figure drawn for the endpapers of Marjorie Pickthall's *The Woodcarver's Wife*, although published a year before MacDonald made a study of Byzantine art in preparation for the St Anne's paintings, demonstrates that his art-nouveau-influenced manner was readily adaptable to the style required for the church – "a style of decoration combining the flat treatment and strong simple colouring of the Byzantine style with the completer illustrative quality of later work, down to Giotto," as he characterized it. Although not the only public art executed by members of the Group of Seven, the St Anne's commission is certainly the most successful and beautiful.

His ecclesiastical chores prevented MacDonald from making any extensive sketching trip in 1923, but in the following year he made the first of seven annual visits to the Rocky Mountains, the area that dominates the work of his last few years. He fell in love with the mountains at once, as he made clear in "A Glimpse of the West," an article written after his first visit:

I got to the beautiful [Lake] O'Hara lying in a rainbow sleep, under the steeps of Mount Lefroy and the waterfalls of Oesa. And there I realized some of the blessedness of mortals. We may reach our Happy Hunting Grounds and return again, if we take the right train.

The Transfiguration

Excerpt from J.E.H. MacDonald's Journals

MacDonald's enthusiasm for the mountains was such that his son wrote how, after one trip west, his father "for weeks ... would talk of little else but rocks, weather, marmots, rock-rabbits, bears, horses and trees, all interspersed with the names of mountains, lakes and trails ... while his listeners vainly tried to stem the tide of mountain lore and get in a word of their own doings." On each of his visits to the Rockies he kept a notebook, and these are full of detailed descriptions of the weather, the colours, the fauna, and the landscape. An excerpt from one of these journals (undated, but certainly 1925) will give their flavour:

Fri. Sept. 11. Welcome signs of clearing today & everybody cheering up. Soft English mists everywhere & sun glimmering through. Rain at times during last night. Much snow on Mtns. now visible. Day continued very unsettled however, with many showers & marvellous changing effects of cloud movement among mts. West of [U.A.?] trail & made sketch of larches now turning finely: ahead of last year in date. Very cold up there, [illegible] nature in full days. After supper cards, theosophy & other mixtures. Home through the mud & the darkness & just a star or two showing.

In the mountains, as he put it in the 1929 notebook, MacDonald found an "endless variety of subjects" to sketch.

In passing, it is worth commenting on MacDonald's amusingly sly reference to "cards, theosophy & other mixtures." A number of his friends and acquaintances were members of a theosophical lodge – Lawren Harris most importantly, but also Bertram Brooker, F.B. Housser, Roy Mitchell, and William Arthur Deacon, for example – and theosophical ideas were very much a part of the artistic and intellectual milieu of Toronto in the 1910s and 1920s. MacDonald's wife Joan was a devout Christian Scientist, as was at least one member of the Group of Seven and such colleagues as Eric Brown. MacDonald himself adhered to neither of these sects; as he admitted in a letter to Brooker, he disliked "anything of the occult or secret doctrine." He grew up in the Church of England (not the Presbyterian Church, as A.Y. Jackson mistakenly thought), but as an adult he was apparently not a practising Christian. "I never remember him going to church, though he liked to hear the bells and felt he owed

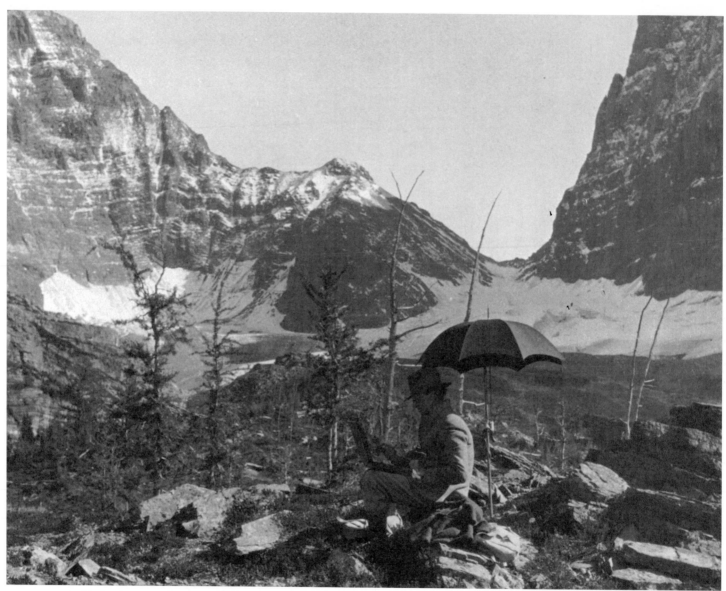

J.E.H. MacDonald Sketching, Opabin Mountains

the church something on that account," his son once remarked. Nothing in MacDonald's published writings, however, suggests atheist or agnostic tendencies; he seems therefore to have been a theist largely without interest in the dogma and practices of organized religion.

The middle 1920s were crucial in the establishment of the Group of Seven's reputation. In the spring of 1924 a large selection of Canadian paintings was exhibited as part of the British Empire Exhibition at Wembley, outside London. The choice of the pictures caused a good deal of resentment and friction between the old and the new guard in Canada because Eric Brown of the National Gallery of Canada cleverly acquired permission to appoint the jury in order to minimize the influence of the Royal Canadian Academy. Of the Group, only Arthur Lismer was a jury member, and indeed the jury's constitution was fairly evenly balanced between the conservatives and the modernists.

Hector Charlesworth of *Saturday Night*, long a critic of the new painting, fumed in print about "the Toronto blood and thunder school" with its "narrow and rigid formula of ugliness." By contrast, the British press found the exhibition quite exciting. An English art critic, Rupert Lee, was commissioned to review the show for the *Canadian Forum*, and he found ample evidence that "Canadian art ... is very much alive." His *Forum* piece on the 1925 Wembley exhibition was more specific in its recognition of the desire of Canadian painters "to express the wild and unexplored beauties of a new landscape." Among the works of MacDonald exhibited in the 1924 show was *The Solemn Land*, which Lee commented on rather uncommittedly: "In *The Solemn Land*, J.E.H. MacDonald seems to be exercised with an emotion which is well expressed in the title." He was much more enthusiastic about Lismer and Varley.

The two Wembley shows did a great deal to attract international attention to the Group of Seven's aesthetic and to make the new landscape painting better known abroad. In January 1925, the fourth Group show was held at the Art Gallery of Toronto. The printed catalogue for the third exhibition had spoken fervently of how art "must take to the road and risk all for the glory of a great adventure." This rather

more than usually contentious text may have prepared the critics for the continuation in 1925 of a pugnacious stance by the six exhibiting members of the Group. (The Hamilton-born Montreal painter Albert Robinson made up the seventh in the 1925 show, although he was not an official member of the Seven.) The notices were in any case rather mixed, Charlesworth not being alone in voicing disapproval of the "Group System." MacDonald exhibited some of his mountain canvases for the first time, including the heavily stylized and flat *Rain in the Mountains*, a transitional picture that uncomfortably combines features of his Algoma style (in the rock and tree in the foreground) and the newer approach he was developing in response to the western mountain landscape (the two-dimensional mountain and sky in the upper half of the work). Barker Fairley dismissed this painting as "a fine idea, but ... not a canvas" and complained that "we cannot be satisfied with [MacDonald's] hasty decorations." *Mount Goodsir, Yoho Park*, also shown in 1925, is much more unified stylistically, with the decorative element completely dominant.

There was another Group show in 1926, but that year was more notable for the publication of F.B. Housser's *A Canadian Art Movement*, which came out in December. Housser was a well-to-do journalist who wrote for the financial pages of the *Daily Star*. His wife was the painter Yvonne McKague Housser, and they shared with the Group of Seven more than an interest in art. Housser was a theosophist and an enthusiast of Whitman, whose name is evoked several times in the book. The importance of theosophy to the artistic circles in which the Group moved has already been mentioned but the influence of Whitman was scarcely less. One art historian has included Housser and MacDonald with R.M. Bucke, the London, Ontario, psychiatrist, as forming the trio most active in promoting Whitman's reputation in Canada. Only two months before the publication of *A Canadian Art Movement*, MacDonald gave a lecture entitled "An Artist's View of Whitman" at the old Central Reference Library. (Emma Goldman was in the audience and apparently sprang to MacDonald's defence at one point when another listener criticized his views.) He admitted at the outset that he was not a Whitman scholar, while at the same time setting the tone with the statement that he

had "accepted him as air & sunlight. & a liberator of the soul." There was a Whitman fellowship in Toronto in the 1920s, and a growing "cult of Whitman," as William Arthur Deacon characterized it. If theosophy had permitted canonization, Whitman would certainly have been made a saint, as the two cults were intimately linked.

Housser's book had a remarkable success, and as unscholarly as it now seems, it did much to enshrine the Group of Seven in Canadian art history. Hugh Eayrs, the young director of Macmillan of Canada who worked hard to further Canadian art and literature in the 1920s, had a thousand copies of the book printed, and in less than a year this first impression was exhausted. Over 100 copies were sent out for review or presentation, and 570 were sold at a retail price of $2.50. A further 731 copies were sold at a slightly reduced price, the book meanwhile having been reprinted in October-November of 1927. By the time the type was ordered distributed in 1929 and the book remaindered the following year, some 1500 copies were in print: hardly a bestseller, but the publisher and author must certainly have been pleased. The sales figures demonstrated a widespread public interest in the Group's work, and Housser's high praise ("This parable of the Group of Seven movement shows that when the soul of a man and the soul of his people and environment meet, the creative genius of a race bursts into flame") solidified the painters' reputation as the most important group of artists ever to work in Canada. The book also had the effect of giving chapter and verse to some rather superficial views of the Group which have remained part of its myth, a fact which Barker Fairley hinted at in his review of the book in the *Canadian Forum*.

A mixed review in an Ottawa newspaper by Martin Burrell explicitly connected Housser's book with Whitman:

If in Whitman's enthusiasm to announce a new gospel we find so much uncouthness in the framing of the message, so it is not unlikely that in these manifestations of a new "Canadian Art Movement" there will be found many examples of crudities and defects. They may, indeed, be only the defects of the artists' qualities, yet defects after all, and the wayfaring man, though a fool, may see them.

For his part, MacDonald, however critical he was of certain details in the famous letter never sent, thought Housser's book "very encouraging. It makes me want to go on towards that Canadian ideal."

As the 1920s wore on, MacDonald grew increasingly busy at the Ontario College of Art. The college decided to give George Reid a year's paid leave in the summer of 1928, and MacDonald agreed to be acting principal in his absence. (It is interesting to note that, although a member of the old guard, Reid had started painting in the Algoma region in the mid-1920s, no doubt in part at MacDonald's urging. His paintings, not surprisingly, formalized the wilderness much more than those of his younger colleague.) In that same summer and again the following autumn, MacDonald worked on two architectural design commissions. First he designed the lobby of the Claridge Apartments on Avenue Road in Toronto, although the painting itself was done by Carl Schaefer. Working with the architectural firm of Baldwin and Green, together with his son, he also designed decorations for the Concourse Building at 100 Adelaide Street West, an instant landmark when it opened in February 1929 but now rather dwarfed by First Canadian Place and other circumambient giants. On the outside of the building there is a coloured mosaic over the main entrance and "coloured tiling on the turret facings" (Lismer's words) at the top of the structure, these latter representing birds, among other things. Inside, in the lobby, are paintings of flora and fauna interlarded with passages from a number of Canadian poets. Other commissions in these years included the book design for Laura Salverson's *Lord of the Silver Dragon* (1927), as well as minor work such as the covers he executed for Sheridan Nurseries catalogues in 1928 and 1929.

It is not surprising to find Thoreau MacDonald recording in his notebook in 1927 that "my father is trying to paint these days but has little time." Despite his annual sketching trips to British Columbia, MacDonald's output in the late 1920s and early 1930s was modest. His visits to the Rockies ended in 1930. By then he was the principal of OCA, a job which left him little time to work. There were Group of Seven shows in 1928, 1930, and 1931 where he exhibited a few of his western paintings. In the fall of

Barbados

1931 he was elected to full membership in the Royal Canadian Academy, but in November he succumbed to a stroke. It was the beginning of his last full year of life, and after recuperating he was given leave from the college so that he and his wife could spend the worst months of the winter in the sun. At the end of January 1932, they took the train to Boston and from there sailed on HMS *Drake* for Barbados.

Details about the Barbados trip have been preserved in a journal that MacDonald kept at the suggestion of Doris Heustis Speirs, a Toronto painter friend who literally thrust a blank book into his hands at the train station. The diary, which has been published, is not a long one, but it is full of fascinating detail perceived with a painter's eye and rendered in simple but effective prose. An excerpt dated February 8, 1932, demonstrates its qualities:

Shore line leaving Nevis with St. Kitts dim in the north. Color a clean almost sulphur green with warm olive mottlings and blue green shadows.

Today at St. Kitts, the shore boats crowding round the gangway of this vessel most attractive in color, bright tints faded and harmonized. One especially painted bright blue inside, its seat covered with red orange drapery, the thwarts in grey ochre and a number of rope ends of the same color, making a fringe over its sides. Its stern flagpole was topped with large orange and crimson flowers, the man in faded khaki and ochre ...

There are ink sketches scattered throughout the journal. During the trip, MacDonald also did sketches in oils, which have the lyrical, loose quality of most of his oil sketches, so it is hard to say how they would have been transformed if he had lived to enlarge them into easel paintings. But several critics have commented on the stylistic change they appear to represent, especially in how he rendered the quality of the light.

MacDonald returned to Toronto in April, and between then and the beginning of the school year in September, he worked on three mountain canvases in a hastily

made studio in Thornhill. Two of these are among the most important pictures of this last period. *Goat Range, Rocky Mountains* and *Mountain Snowfall, Lake Oesa* together embody two opposing aspects of the mountain landscape and, not incidentally, of MacDonald's view of nature. The first emphasizes the grandeur and the forbidding face of the Rockies, a craggy slope in the foreground, remote, precipitous peaks in the background. The second is quiet and lyrical, almost intimate (if rocks can be said to be intimate). The all-over effect of the snow creates a sense of calm, to which is added a feeling of infinite depth in the greenish blue of the mountain lake in the painting's midground. The picture is a perfect realization of MacDonald's contention that "to paint from nature is to realize one's sensations, not to copy what is before one."

MacDonald returned to his teaching and administrative duties in September 1932 and threw himself back into his work. He was present at a staff meeting on November 17. But five days later, in his office, he suffered another stroke, and on November 26 he died. The funeral on the twenty-ninth was conducted by H.G. Wallace, a Christian Scientist. The pallbearers included four members of the Group of Seven (Harris, Jackson, Johnston, and Lismer), as well as Fred S. Haines, who became the new principal of OCA. MacDonald was six months short of his sixtieth birthday.

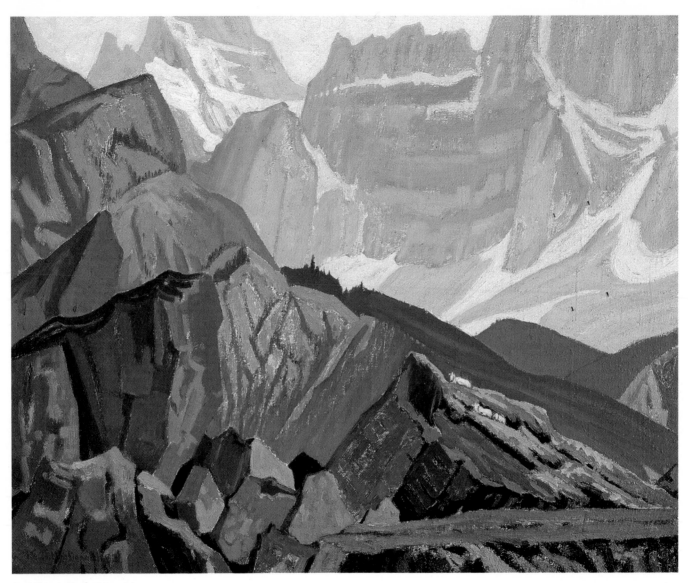

Goat Range, Rocky Mountains

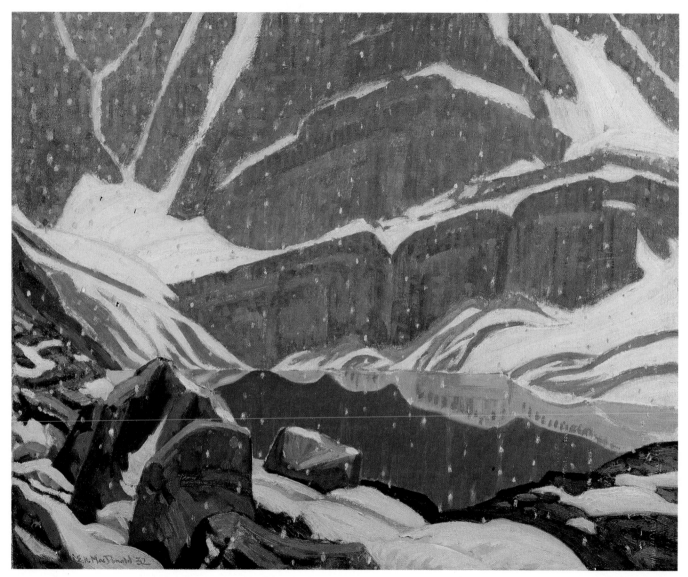

Mountain Snowfall, Lake Oesa

MacDonald's Legacy

IN 1931, THE YEAR before MacDonald's death and the year in which the last Group of Seven exhibition took place, the poet Charles G.D. Roberts published a short essay entitled "A Note on Modernism" in *Open House*, an anthology co-edited by William Arthur Deacon and issued by Graphic Publishers, a Canadian publishing house that embodied the nationalist spirit of the 1920s. At the end of the essay, which is mainly about literature, Roberts refers to the Group of Seven to illustrate his contention that modernism basically meant reaction. He describes the Group as "well armed and more than ready for battle," but then notes that "its militancy finds so little to militate against that it doffs its armour and hides its hatchet under its blouse. Somewhat to its disappointment, perhaps, it finds the exponents of the older school of art for the most part more curious than hostile. Some of them, even, coming to curse, remain to bless."

So soon, it seems – although only just soon enough for J.E.H. MacDonald – were the Group's battles pretty much won. The 1930s had scarcely begun when they found themselves beginning to make the transition from Young Turks to Establishment figures. A kind of obituary for the Group appeared in the January 1932 issue of the *Canadian Forum*; and although F.B. Housser took up the cudgels in a long piece in response that was published the following month, the fact remained that the Group of Seven had come to an end, only to be replaced by the Canadian Group of Painters. Thoreau MacDonald himself remarked that "something different must be done." It was only a matter of time before the young would find common cause in opposing the Group's ideas. Harris alone followed the avant-garde into abstract painting.

The fame of the Group nevertheless assured that MacDonald's reputation would never be in eclipse. Memorial exhibitions were mounted in 1933 in Toronto and Ottawa, and in 1936 a large Group retrospective was organized by the National Gallery. With that show one begins to note the canonization of the seven painters: the *Canadian Forum* review stated simply that "with its advent, Canadian art began." Five years after his death, an exhibition of nearly a hundred of MacDonald's paintings was put on at the Mellors Galleries in Toronto, combining works from private and public collections with some twenty-five canvases from the estate which were for sale. Two years later, the same gallery exhibited almost forty MacDonald pictures together with a dozen Tom Thomsons, most of which were again for sale. In 1947, the Dominion Gallery in Montreal mounted a "memorial exhibition" of thirty-nine canvases and a quantity of sketches, drawings, etchings, and other minor work, much of which was for sale. The Art Gallery of Hamilton, which had acquired some important pieces, included them in a one-man retrospective in March 1957 among over sixty works. Most importantly, the Art Gallery of Toronto produced a major exhibition of one hundred and three of MacDonald's paintings and oil sketches in 1965. That show also travelled to Ottawa, and its catalogue, by Nancy Robertson, remains an essential reference work.

MacDonald's son Thoreau worked diligently to sustain and increase his father's reputation. Two catalogues for exhibitions enumerated above contain notes by him, and he remained a tireless proselytizer until his death in 1992. In his friend Lorne Pierce, the editor of The Ryerson Press, Thoreau had a powerful ally. Pierce was a publisher of strong nationalistic feelings who was devoted to literature and the arts in general. His admiration for MacDonald (at one time he owned *The Elements*) resulted in several books and ephemeral pieces being published by Ryerson. In his own A *Postscript on* J.E.H. *MacDonald* (1940), which was issued privately, he described the painter as "a genius, original in a way and many sided, though neither complex nor abstract." For the Canadian Artists Series, Pierce commissioned a small book by A.H. Robson, MacDonald's former boss at the Grip shop. Despite its brevity – it has

only eight pages of biographical text, although the illustrations and their descriptions flesh it out to thirty-two in all – it was the first separate book on MacDonald's life and work, and important for that reason alone. Its appearance was timed to coincide with the 1937 Mellors Galleries exhibition.

Pierce was the publisher of *West by East* and the facsimile of MacDonald's first book design, which Ryerson issued as its 1945 Christmas card. Most important of all, however, was Ryerson's publication in 1940 of E.R. (Bob) Hunter's *J.E.H. MacDonald: A Biography & Catalogue of His Work*. For almost forty years this was the standard work on MacDonald, and it remains valuable to the extent that it incorporates notes and testimony from the painter's friends and family. Thoreau MacDonald in particular was closely involved in the preparation of the book, in addition to designing it for Pierce. But it was not a notable success; although only five hundred copies were printed, Ryerson had to remainder it for 49¢ in 1948. Perhaps its appearance during the early years of the Second World War worked against it. The catalogue raisonné appended to the biographical portion of the book is, of course, long out of date, but it remains an essential starting point for all scholarly work on MacDonald's *oeuvre*.

The biographical section of Hunter's book was largely supplanted in 1978 by the publication of Paul Duval's *The Tangled Garden: The Art of J.E.H. MacDonald*. Duval's text was based on archival material (oddly, not assembled into any list of sources consulted), and it brought into print for the first time much new information about the painter. The book also reproduced a large number of MacDonald's paintings, sketches, and other work. *The Tangled Garden* is not a proper critical biography; one might indeed complain of it that it is a little too worshipful of its subject. All the same, it is an indispensible study of MacDonald's life and work on which future criticism will have to build.

The process of taking stock of the Group of Seven's influence and achievement commenced shortly after MacDonald's death. In a retrospective article published in *Queen's Quarterly*, H.R. MacCallum began by emphasizing the Group's connections to traditional painting, but concluded with the prediction that their innovative

approach to art would have "wide repercussions upon all phases of our national life" for "the next fifty or a hundred years." Such a claim may seem excessive until one stops to think about how pervasively certain images created by the Group have infiltrated the Canadian imagination. In Gallery No. 109 of the National Gallery of Canada where MacDonald's *The Solemn Land* hangs, as mentioned at the beginning of this book, Varley's *Stormy Weather, Georgian Bay* and Lismer's *September Gale, Georgian Bay* may also be found. All three, executed in 1920-21, were acquired by the Gallery in the 1920s as contemporary work. All three are among the most famous painted images ever created in Canada. Few Canadians, if pressed, could recite a poem by Roberts or Pratt or Layton, and fewer still could recognize, much less hum, a piece by Claude Champagne or Harry Somers. But the northern imagery of the Group of Seven may be described legitimately as a common cultural inheritance. Elementary and secondary schools across the country are decorated with reproductions of their paintings. The Canadian equivalent of visiting Napoleon's tomb or Poets' Corner in Westminster Abbey is looking into Tom Thomson's shack on the grounds of the McMichael Gallery at Kleinburg, north of Toronto. The highest price ever paid at auction for a Canadian painting was for a Group of Seven work: a Lawren Harris canvas that fetched just under half a million dollars in 1986. For all the attempts by historians and art critics to circumscribe the Group's work by emphasizing its limitations – the absence of people, the regional bias, the stylistic similarity of the seven painters at a certain time, and so on – the popular perception remains of the Group of Seven having captured the true spirit of Canada. The McMichael collection itself originated in precisely that apperception.

The rapid change in the Group of Seven's reputation "from scapegoat to sacred cow," as Thoreau MacDonald expressed it in his little book on the Group – a progression that occurred early, perhaps too early, in the careers of the seven painters – together with the symbolic quality that a small number of his paintings has acquired in the public mind, has meant that MacDonald's achievement as a whole has been neither fully recognized nor adequately appraised. Art historians and curators have

looked more and more closely over the past two decades at the artistic, intellectual, and philosophical influences that formed the Group's shared inheritance. The result is that we are now better able to judge the relationship of MacDonald to contemporary northern European landscape painting or to pinpoint the various ways in which theosophical, Whitmanian, and other occult and pseudo-occult movements played a role in his life and art. At the same time, we lack a number of the fundamental sources necessary to an informed critical study of his work: a catalogue of his graphic and design work (Hunter Bishop, the late archivist of the Arts and Letters Club, began such a project and Robert Stacey has inherited it), an edition of his letters, and an edited volume of his essays and lectures, to say nothing of a full-scale biography. Surely much remains to be discovered, for example, about his early work (from the 1890s until his return from England in 1907) both as a painter and as a commercial artist.

Even given the very partial state of our knowledge of MacDonald's complete output, however, a few generalizations about his work can be made. William Colgate called MacDonald "one of the few great designers Canada has yet produced," and it is the design sense that underlies all of his work in whatever form it took. Few other Canadian artists have turned their hand to such a variety of creative work as MacDonald: painting and drawing, of course, but also book design, binding design, commercial advertising, lettering, heraldry, stage design, architectural decoration, and even the design of coins. (His designs for the reverse of the five-cent and twenty-five-cent coins, submitted to a competition in 1927 for the Jubilee coinage, both won first prizes of $500, but time constraints prevented the coins from being minted.) His design sense and training as a commercial artist, if they sometimes worked to trivialize a landscape painting, mainly had the salutary effect of formalizing MacDonald's poetic temperament and helped thereby to keep most of his painting on the near side of private symbolism. Speak as he did once of "that mystic north round which we all revolve," a mystical or spiritualist sensibility is rarely foremost in his work. The

coolness of Carmichael or Casson or the other-worldly self-indulgence of some of Harris's and Varley's paintings were not his way.

In MacDonald's finest work, his design training is in perfect harmony with an open and instinctive sensibility that is lyrical or austere in appropriate proportion to the piece of the world by which it is temporarily captured. Greater personal responsibilities as well as failing health made it more difficult for him to achieve that wonderfully efficacious balance as his life moved towards its close, although a late painting such as *Mountain Snowfall, Lake Oesa* comes close. But in the years between his illness of 1917 and the early 1920s, when his physical prime corresponded with his discovery of the Algoma landscape in the company of Harris, Johnston, and Jackson, he produced painting after painting that brilliantly counterpoised these two constituent parts of his artistic character.

It is difficult to assess MacDonald's influence on later Canadian art apart from the general influence of the Group. His antipathy towards non-objective art limited his attractiveness to the painters of a younger generation, and in this respect a lesser painter like Bertram Brooker was of far greater interest to them. Such painters as Carl Schaefer and Illingworth Kerr were among MacDonald's students at the Ontario College of Art, and his example, if not necessarily his exact style, impressed them and others deeply. Thoreau MacDonald, needless to say, carried on the tradition of his father's work in book design and the other graphic arts, but as a painter he is a minor figure (he was, in fact, colour blind). It is not likely that later important Canadian designers like Allan Fleming, Robert Reid, or Carl Dair would have learned much directly from MacDonald's example, as his art-nouveau approach was out of date by the time they began working in the 1940s and 1950s. It can be argued that the accession of the Group of Seven to almost unassailable control of Canadian painting in the mid-1920s had the perverse effect of limiting its immediate legacy. J. Russell Harper cites a remarkable 1927 letter from Clarence Gagnon to Eric Brown in which Gagnon, who was not unsympathetic to the Group's approach to picture-making,

complains even at that early date of their success. "The younger generation of artists," he notes, "seeing that they cannot enter the House of Seven because all of the Seven Rooms are occupied by the Seven Wise Men, rather than sleep on the steps will move along and build a house of their own."

This is, one might note, exactly as it should be in the course of the development of any art. Indulging in a fantasy though it is, one cannot resist pointing out that MacDonald himself would probably have thought the work of J.W.G. MacDonald (no relation) or that of Jean-Paul Riopelle, had he lived to see it, little more than "hot mush."

But this is to take nothing away from MacDonald's accomplishments. As a human being and as an artist he was highly regarded by his contemporaries, and much of his work remains fresh and compelling today. Naturally it enshrines some characteristics ambivalently perceived in a postmodern culture, but its enduring qualities transcend stylishness and fashion as inelusively as all great art. In a letter written towards the end of his life to the Council of the Ontario College of Art, whose chairman, Frederick Bridgen, had written to him suggesting that he might wish to resign as principal for health reasons, MacDonald remarked sadly on how his responsibilities prevented him from painting and other creative work. "I sometimes dream," he wrote in an almost elegiac frame of mind, "that I might produce something worthy of the pioneer work in which I had a share." Unquestionably he did produce much worthy of the pioneering efforts of the Group of Seven, and must finally be counted among the most important Canadian painters of the twentieth century.

J.E.H. MacDonald Sketching,
Sturgeon Bay

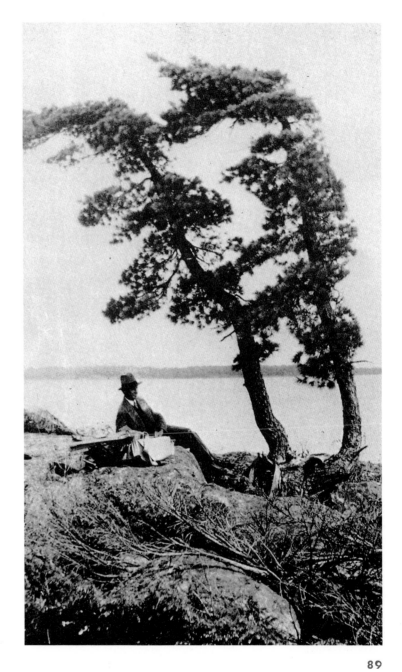

List of Illustrations

Selected Bibliography

GENERAL WORKS

Art Gallery of Hamilton. *J.E.H. MacDonald, 1873-1932*. Hamilton: Art Gallery of Hamilton, 1957.

Arts & Letters Club of Toronto. *The Year Book of Canadian Art 1913*. London and Toronto: J.M. Dent & Sons, 1913.

Bridle, Augustus. *The Story of the Club*. Toronto: The Arts & Letters Club, 1945.

Casson, A.J. 'Group Portrait' *Saturday Night* 101, 3 (March 1986): 34-38.

Colgate, William. *Canadian Art: Its Origin and Development*. Toronto: The Ryerson Press, 1943.

Davidson, Margaret F.R. 'A New Approach to the Group of Seven' *Journal of Canadian Studies* 4, 4 (November 1969): 9-16.

Dominion Gallery. *J.E.H. MacDonald, Memorial Exhibition*. Montreal: Dominion Gallery, [1947].

Duval, Paul. *Group of Seven Drawings*. Toronto: Burns and MacEachern, 1965.

— *The Tangled Garden: The Art of J.E.H. MacDonald*. Scarborough: Cerebrus Publishing and Prentice-Hall, 1978.

Fairley, Barker. 'The Group of Seven' *Canadian Forum* 5 (February 1925): 144-47.

Harper, J. Russell. *Painting in Canada: A History*. 2nd ed. Toronto: University of Toronto Press, 1977.

Housser, F.B. *A Canadian Art Movement: The Story of the Group of Seven*. Toronto: Macmillan of Canada, 1926.

— 'The Group of Seven and Its Critics' *Canadian Forum* 12 (February 1932): 183-84.

Hunter, E.R. *J.E.H. MacDonald: A Biography & Catalogue of His Work*. Toronto: The Ryerson Press, 1940.

Landry, Pierre B. *The MacCallum-Jackman Cottage Mural Paintings*. Ottawa: National Gallery of Canada, 1990.

MacCallum, H.R. 'The Group of Seven, A Retrospect' *Queen's Quarterly* 49, 2 (May 1933): 242-52.

MacDonald, J.E.H. 'ACR 10557' *Lamps* (December 1919): 33-39.

— 'Art and Our Friend in Flanders' *Rebel* 2, 5 (February 1918): 182-86.

— 'Art Crushed to Earth' *Rebel* 2, 4 (January 1918): 150-53.

— *The Barbados Journal 1932*. Ed. John W. Sabean. Kapuskasing: Penumbra Press, 1989.

— *Bookplate Designs by J.E.H. MacDonald*. Thornhill: Woodchuck Press, 1966.

— 'Bouquets From a Tangled Garden' *Globe* March 27, 1916: 4.

— 'The Canadian Spirit in Art' *Statesman* 1, 35 (1919): 6-7.

— 'The Choir Invisible' *Canadian Forum* 3 (January 1923): 111-13.

— 'City of Future Brilliant With Gold and Colour' *Evening Telegram* February 26, 1929: 28.

— 'The Decorations at St Anne's Church, Toronto' *Journal of the Royal Architectural Institute of Canada* 2, 3 (May-June 1925): 85-93.

— 'A Glimpse of the West' *Canadian Bookman* 6, 11 (November 1924): 229-31.

— 'A Happy New Year for Art' *Rebel* 4, 4 (January 1920): 155-60.

— 'A Hash of Art' *Rebel* 2, 3 (December 1917): 90-93.

— 'The Hot Mush School, in Rebuttal of H.F.G.' Toronto *Daily Star* December 18, 1913: 23.

— 'In Memoriam, Robert Holmes, RCA' *Tangent* (1931): 4-6.

— 'A Landmark of Canadian Art' *Rebel* 2, 2 (November 1917): 45-50.

— 'Mentioned in Dispatches' *Rebel* 3, 5 (March 1919): 205-07.

— *My High Horse*. [Thornhill]: Woodchuck Press, 1934.

— 'A Notable Exhibition of Decorative Art' *Globe* April 29, 1916.

— 'Scandinavian Art' *Northward Journal* 18/19 (1980): 9-35.

— *Sketchbook, 1915-1922*. Introduction by Hunter Bishop. Moonbeam: Penumbra Press, 1979.

— 'The Terrier and the China Dog' *Rebel* 3, 2 (December 1918): 55-60.

— *Village & Fields: A Few Country Poems*. Thornhill: Woodchuck Press, 1933.

— *West By East and Other Poems*. Toronto: The Ryerson Press, 1933.

— 'A Whack at Dutch Art' *Rebel* 2, 6 (March 1918): 256-60.

— *A Word To Us All*. Toronto: The Ryerson Press, 1945.

MacDonald, Thoreau. *The Group of Seven*. Toronto: The Ryerson Press, 1944.

— *Notebooks*. Moonbeam: Penumbra Press, 1980.

McInnes, G. Campbell. 'Upstart Crows' *Canadian Forum* 16 (May 1936): 14-16.

Mellen, Peter. *The Group of Seven*. Toronto: McClelland & Stewart, 1970.

Mellors Galleries. *Catalogue [of] A Loan Exhibition of the Work of J.E.H. MacDonald, RCA*. Toronto: Mellors Galleries, 1937.

— *Exhibition of the Work of Tom Thomson and J.E.H. MacDonald*. Toronto: Mellors Galleries, 1939.

Pantazzi, Sybille. 'Book Illustration and Design by Canadian Artists 1890-1940' *National Gallery of Canada Bulletin* 4, 1 (1966): 6-24.

Pierce, Lorne. *A Postscript on J.E.H. MacDonald, 1873-1932*. Toronto: The Ryerson Press, 1940.

Robertson, Nancy E. *J.E.H. MacDonald, RCA, 1873-1932*. Toronto: Art Gallery of Toronto, 1965.

Robson, Albert H. *J.E.H. MacDonald, RCA*. Toronto: The Ryerson Press, 1937.

Stacey, Robert. 'A Contact in Context: The Influence of Scandinavian Landscape Painting on Canadian Artists Before and After 1913' *Northward Journal* 18/19 (1980): 36-56.

OTHER SOURCES

Bridle, Augustus. 'Seven Painters, Six Poets in Revel [sic] Revues This Week' Toronto *Daily Star* May 23, 1936: 23.

Burrell, Martin. 'A New Art Movement' in his *Betwixt Heaven and Charing Cross*. Toronto: Macmillan of Canada, 1928, : 163-71.

Call, F.O. *Acanthus and Wild Grape*. Toronto: McClelland & Stewart, 1920.

Charlesworth, Hector. 'Canada and Her Paint Slingers' *Saturday Night* 39, 51 (November 8, 1924) : 1.

— 'Pictures That Can Be Heard' *Saturday Night*, March 18, 1916.

Colgate, William. *The Toronto Art Students' League, 1886-1904*. Toronto: The Ryerson Press, 1954.

Davis, Ann. *The Logic of Ecstasy: Canadian Mystical Painting*. Toronto: University of Toronto Press, 1992.

Djwa, Sandra. 'A new soil and a sharp sun': The Landscape of a Modern Canadian Poetry' *Modernist Studies* 2, 2 (1977): 3-17.

[Fairley, Barker]. 'The Group of Seven' *Canadian Forum* 7 (February 1927) 136.

Gadsby, H.F. 'The Hot Mush School' Toronto *Daily Star* December 12, 1913: 6.

Housser, Bess. 'In the Realm of Art' *Canadian Bookman* 7, 2 (February 1925) 33.

Housser, F.B. 'The Amateur Movement in Canadian Painting' in Bertram Brooker, ed. *Yearbook of the Arts in Canada 1928-1929*. Toronto: Macmillan of Canada, 1929: 83-90.

Jackson, A.Y. *A Painter's Country: The Autobiography of A.Y. Jackson*. Memorial ed. Toronto: Clarke, Irwin, 1976.

Jefferys, C.W. 'MacDonald's Sketches' *Lamps* (December 1911) 12.

Johnston, George. *Carl: Portrait of a Painter.* Moonbeam: Penumbra Press, 1986.

Lacombe, Michel. 'Theosophy and the Canadian Idealist Tradition: A Preliminary Exploration' *Journal of Canadian Studies* 17, 2 (Summer 1982): 100-18.

Lee, Rupert. 'Canadian Art at Wembley' *Canadian Forum* 5 (September 1925): 368-70.

— 'Canadian Pictures at Wembley' *Canadian Forum* 4 (February 1924): 338-39.

Lismer, Arthur. 'Art Appreciation' in Bertram Brooker, ed. *Yearbook of the Arts in Canada 1928-1929.* Toronto: Macmillan of Canada, 1929, : 59-71.

MacCuaig, Stuart. *Climbing the Cold White Peaks: A Survey of Artists in and from Hamilton 1910-1950.* Hamilton: The Hamilton Artists' Inc., 1986.

MacDonald, J.E.H. Personal papers. National Archives of Canada, MG30 (D111). (Contains drafts of lectures, journals, correspondence etc.)

MacDonald, Thoreau. 'Decline of the Group of Seven' *Canadian Forum* 12 (January 1932): 144.

— Personal papers. Thomas Fisher Rare Book Library, University of Toronto. (Contains journals, letters etc.)

Macmillan of Canada. Archive. Division of Archives and Research Collections, McMaster University Library. (Contains material on the publishing history of Housser's *A Canadian Art Movement,* 1926.)

McGregor, Gaile. *The Wacousta Syndrome: Explorations in the Canadian Langscape.* Toronto: University of Toronto Press, 1985.

McLeish, John A.B. *September Gale: A Study of Arthur Lismer of the Group of Seven.* 2nd ed. Toronto: J.M. Dent & Sons, 1973.

Murray, Joan. 'Graphics in the Forum 1920-1951' *Canadian Forum* 50 (April-May 1970): 42-44.

Roberts, Charles G.D. 'A Note on Modernism' in *Open House.* Ed. William Arthur Deacon and Wilfred Reeves. Ottawa: Graphic Press, 1931, pp 19-25.

Salinger, Jehanne Bietry. 'The Group of Seven' *Canadian Forum* 12 (January 1932): 142-43.

Scott, F.R. et al. *New Provinces: Poems of Several Authors.* Toronto: Macmillan of Canada, 1936.

Stacey, Robert. *The Canadian Poster Book: 100 Years of the Poster in Canada.* Toronto and New York: Methuen, 1979.

— 'The Nautical Motif in Bookplates by Canadian Artists' *Canadian Notes & Queries* 44 (Spring 1991): 8-18.

Usmiani, Renate. 'Roy Mitchell: Prophet in Our Past' *Theatre History in Canada* 8, 2 (Fall 1987): 147-68.

Voaden, Herman A., ed. *Six Canadian Plays.* Toronto: Copp Clark Co., 1930.

Wagner, Anton. 'Herman Voaden and the Group of Seven: Creating a Canadian Imaginative Background in Theatre' *International Journal of Canadian Studies* 4 (Fall 1991): 145-64.

— 'Herman Voaden's New Religion' *Theatre History in Canada* 6, 2 (Fall 1985): 187-201.

Whiteman, Bruce, ed. *A Literary Friendship: The Correspondence of Ralph Gustafson and W.W.E. Ross.* Toronto: ECW Press, 1984.

Acknowledgments

I AM GRATEFUL to a number of friends and colleagues who provided me with information used in the preparation of this book. Robert Stacey gave me access to his large collection of MacDonald's graphic work and directed me to other sources, in addition to encouraging my project. His willingness to share his ongoing research on MacDonald was exemplary. Richard Landon of the Thomas Fisher Rare Book Library, University of Toronto; Carl Spadoni of the Division of Archives and Research Collections, McMaster University Libraries; Anne Goddard of the National Archives of Canada; and David Kotin of the Canadian History Section, Metropolitan Toronto Central Library, all helped me to use material in their care. The staff of the libraries of the Art Gallery of Ontario and the National Gallery of Canada welcomed my inquiries and made my work easier.

Linda Morita at the McMichael Canadian Collection and Charles Hill at the National Gallery of Canada assisted me with photographs of MacDonald, and Mr Hill in particular received a novice into his office, without an appointment, with grace and an open mind. John Mappin arranged for me to borrow and to photograph one of MacDonald's illuminated manuscripts, which had passed through his hands into a private collection. The staff of the Interlibrary Loans Department at McGill University were unfailingly helpful, and Jack Goldsmith of the Instructional Communications Centre at McGill made several of the photographs, specifically of material in the Department of Rare Books and Special Collections, McGill University Libraries.

My friend Milt Jewell and my wife Deborah both read the manuscript and offered suggestions for its improvement.

Above all I would like to thank my editor, Douglas Fetherling, for asking me to write this book, for coaxing me through the inevitable tough patches, and for his wise and accurate eye during the editorial stage. — Bruce Whiteman